Watercolour with Love

50 MODERN MOTIFS TO PAINT IN 5 EASY STEPS

LENA YOKOTA-BARTH

CONTENTS

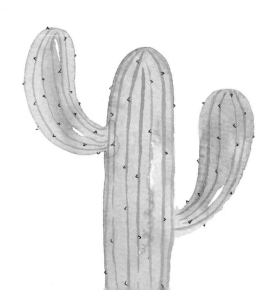

FOREWORD

It's so nice that you are reading these words, because that means you must be interested in a wonderful topic – watercolour. This term is used to describe painting with watercolours, but you can start with any conventional paints. Using watercolours, you can not only create your own artwork, but also relax and unwind from the daily routine at the same time.

My passion for working with these paints did not stem from art lessons at school; this may have been the same for you. It was ever since I came across *etegami* – the Japanese art of watercolour painting – a few years ago that I have not been able to let it go. If I sit down with a brush and paints and a piece of paper, I need to be careful that I am not still painting the following morning. The amazing results that can be achieved with just a few brushstrokes and a little practice are simply captivating.

I hope it gives you as much pleasure as it gives me to try out the colours, to leaf through and work with this book. I would be delighted if you were able to draw inspiration for your own artworks from *Watercolour with Love,* and hope you experience some beautiful, creative moments in your painting – I can't wait to see what you conjure up with a brush and some paint.

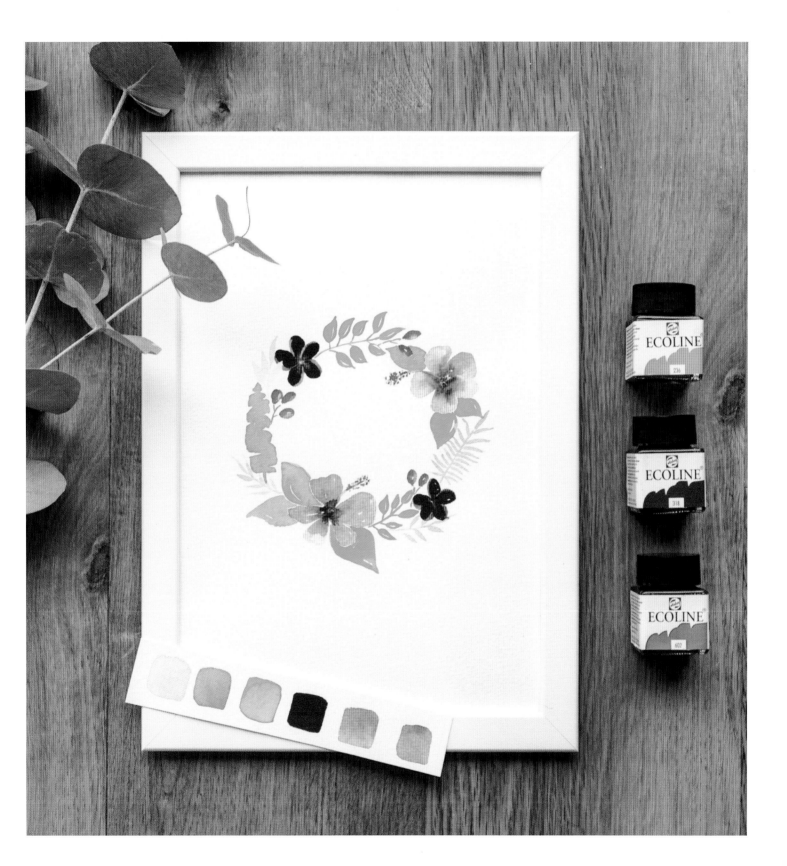

BASICS

You do not need much equipment in order to paint your first watercolour. You probably already have some of it at home. For my first watercolour pieces, I used a block paint set from school and a brush that I had also bought previously. I only had to buy the watercolour paper new. So you see, there is no good reason to put off painting with watercolours.

Before you get started with painting, however, make sure that you have all the materials you need in your creative space, so that you can start your new hobby calmly.

TIP:
If you get too much water on your paper, you can soak some of it up with kitchen paper.

REQUIRED MATERIALS:

Watercolour paper
Watercolour paints
Brushes
Water and water container
Palette
Pencil
Eraser

OPTIONAL MATERIALS:

Kitchen paper
Round object (such as a small bowl) or pair of compasses
Fineliner

TIP:
Always keep some scrap paper handy in order to test your paints for intensity, shade and the amount of water required on the brush before you start painting. Kitchen paper is also very useful if you want to dry off your brush in between strokes, or if you have taken too much paint or water onto the brush.

PAPER

Watercolour paper is categorized according to its texture: rough, cold-pressed (semi-rough) and hot-pressed (smooth). I like to use cold-pressed watercolour paper – from Hahnemühle, for example – which is highly recommended for beginners. It is a bit easier to paint on than Rough paper, as the structure of the paper is not so uneven. You can however use the Rough variety if you want to apply more pigment and detail, and the characteristic structure of the paper needs to remain clearly visible. If you want to write on your watercolour, a smooth watercolour paper is better, as a pencil can pass over the surface without getting caught. Try out the different types of paper for yourself to see which one best suits your style.

Watercolour paper is available in different weights, that is, grammes per square metre. 200–300gsm (90–140lb per ream) are the standard weights. You can buy watercolour paper in blocks, glued along the four edges. While a lot of water is used in watercolour painting, the paper should not distort in the process. It is best to let your picture dry on the block and then remove it carefully afterwards, for example with a bone folder or a fine, sharp knife.

BRUSHES AND DRAWING EQUIPMENT

Brushes come in a variety of shapes: round, flat, fan and many others besides. When painting in watercolour, it is particularly important that the brush can take on lots of liquid or pigment and also release it. There is a general distinction between synthetic and natural-hair brushes: the Kolinsky-Rotmarder (red sable) brush, for example, is particularly suitable as it can hold a lot of liquid due to its natural hair qualities. That said, there are also very good synthetic options nowadays, which have similar properties. Since my preference is to work with synthetic brushes, I use Da Vinci brushes from the Nova Synthetics range and the Universal brushes from Marabu.

When you choose new brushes, take particular care to ensure that they taper to a point. This way, you can paint very thin, as well as very thick, lines with just one brush. The leaf on the right, for example, has been created using just one brushstroke: the shape of the leaf is formed simply by changing the movements of the brush. The tip of the leaf is created by applying just a little pressure on the tip of the brush, which is held at a steeper angle to the paper; the leaf body, by contrast, requires a lot of pressure on the brush, which should be held at a flatter angle.

You can also tell whether a brush is suitable for watercolour painting if you bend the bristles down to one side with your finger and it flicks back into its original shape.

I have used only round brushes of different sizes for the subjects in this book. I have used sizes 6 and 12 the most, in addition to sizes 0, 2, 3, 8 and 16.

As well as brushes, you will find a HB pencil and an eraser helpful for making any sketches and preliminary drawings. You can also use a fineliner for details as an alternative to a fine brush.

TIP:
Never let your brush stand in water after washing it out, as this can cause the bristles to lose their shape.

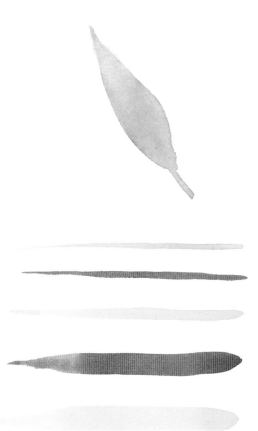

PAINTS

There are also several options to choose from when purchasing paints. Watercolour paints are available in pots, pans and tubes and the choice is, ultimately, a question of taste. For the projects in this book, I have used Ecoline paints. These are transparent liquid watercolours, ready mixed with water and available in pots. They are not waterproof when dry, which means you can continue working on your project at any time by applying water to the already dried paint. The easiest way to get the paint out of the pot is by using a pipette, which is incorporated into the lid. I have specifically used paint numbers 201, 226, 236, 311,318, 361, 381, 390, 411, 506, 545, 601, 602 and 700.

How vibrant or muted you want the colours to appear in each case is left entirely up to you. By adding more or less water, you can achieve anything from pastel to strong, bright shades.

It is best to have two glasses of water to hand when painting. You can either use one glass for cleaning the brush and the other for taking on fresh water, or use one glass when applying redder tones and the other for green/blue tones. Whichever way you choose, you should avoid mixing the paints with each other too much, either on the brush or on the paper; otherwise they may lose their radiance and appear a little dirty.

PAINT APPLICATION

There are essentially two different techniques in painting with watercolours: glazing and laying washes. These two techniques will give your artworks sculptural quality as well as depth, and will help them come alive.

GLAZING/WET-ON-DRY

In glazing, several layers of paint are applied on top of each other. Each layer must be completely dry before the next one is applied. It is important that the colours do not blend into each other in any way.

If different colours are applied on top of each other, they produce new shades. Conversely, if the same colour is layered, the intensity of the colour is increased. Paint layers – even in different transparencies – give your work some additional perspective, as you can see in the leafy branches or floral wreaths (see pages 24–25, 34–35, 42–43, 52–53, 62–65, 76–79, 90–91, 98–99 and 106–107).

WASHES/WET-ON-WET

In contrast to glazing, washes work by using several colours or gradations of colour in a wet state. Wonderful shades of colour can be created, although the paints can be more difficult to control. Painting in watercolour usually means working from light to dark – that is, a project is started with very dilute paints, to which stronger colours are added as the work progresses.

Using this technique, paint your subject or surface area with water or a very dilute layer of paint then dab onto it with a stronger colour, along the edge of the subject. Give the colours time to develop – they will spread slowly over the damp surface and create a wonderful gradation of colour.

Alternatively, you can initially paint the outline of your subject with a strong hue. For the next step, load some clean water onto the brush and pull in the paint over the subject (see the individual steps for 'Cherries', on page 108).

WHITE SPACES

Unlike other media, watercolour painting does not generally use white paint. To be able to portray white spaces, and provide your artwork with more structure, it is useful not to paint the subject in full. Think in advance of areas of your subject that do not need to be painted in. For example, you can depict flowers with just a few brushstrokes if you let some white paper show through between the individual strokes (see 'Rose', pages 54–55). You can also depict reflections or sources of light with some white or very transparent areas.

MIXING COLOURS

PRACTICE TIP:
Before you start to paint a subject, get to know your paints a little better to find out how they react in different situations. Paint some lines or circles, use a little more or a little less water, or mix colours with each other – ideally no more than three.
When you feel more comfortable, you can try painting your first subject. Don't put yourself under pressure, but have fun and try to gain some experience for your subsequent works.

Mixing different colours is probably the hardest part of watercolour painting and requires lots of practice. Don't worry: there are no long drawn-out theories of colour in this book, but it will do no harm to remember art classes at school, where you may have learned about primary and secondary colours.

All other colours can be mixed from the three primaries: red, yellow and blue. If you look at a colour wheel, you will recognize the complementary colours, which lie opposite each other. Using these relationships between colours in your paint choices will help you to create a balanced picture.

For the floral motifs and plants on the following pages, it will help you to mix the shades yourself, especially the green ones. Always use the lighter colour as the base and add the darker hues gradually, as darker colours are very difficult to lighten. You can achieve different colour gradations when you mix the paint with different amounts of water. There is still, however, a huge selection of various ready-mixed paints to fall back on.

On the following pages, you can choose from fifty motifs, which are divided into three levels of difficulty. This way, you can gradually take on increasingly complex projects. For each project, you will find a summary of the most important points – 'Good to Know' – which you should consider when working on the piece.

Have fun painting!

 Introductory level (easy)

 Needs a little practice

 Needs more practice

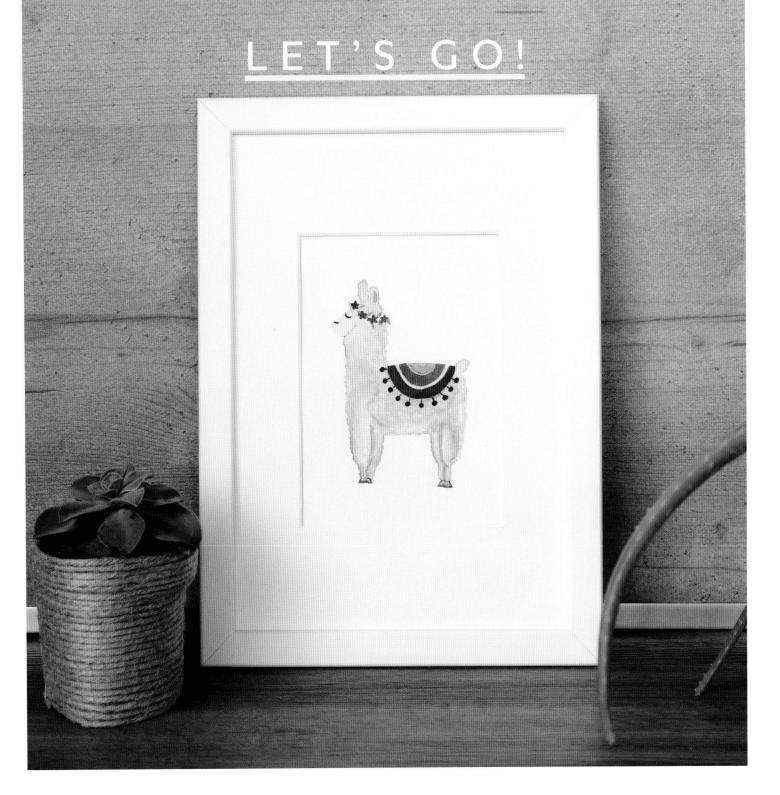

PINEAPPLE

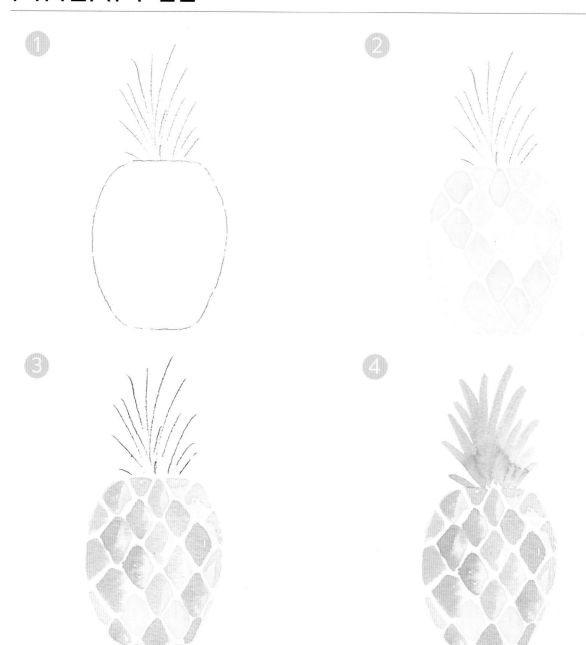

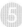

Pay attention to the white areas between the diamonds – these help to depict the shape of the fruit more clearly.

To create an even more dynamic picture, use a light orange tone over some of the yellow areas. Allow the lighter leaves of the pineapple to dry first, before working in the darker green to finish the motif.

RASPBERRY DOUGHNUT

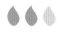

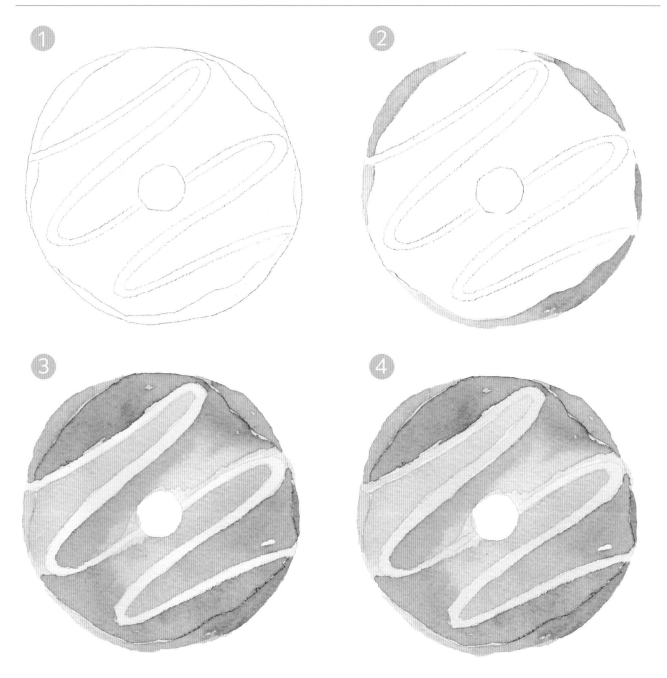

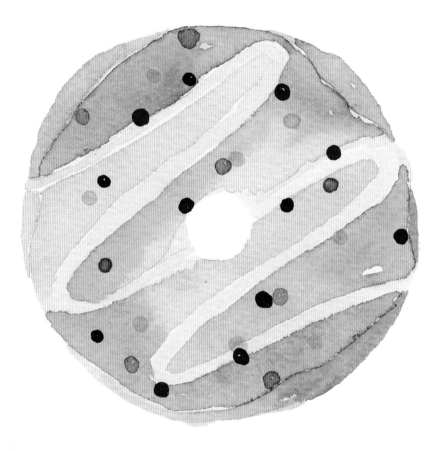

(see page 9).

GOOD TO KNOW: You can vary the colour intensity for the icing as well as the dough by adding more or less water to the pigments. Start with the softest shade, then add a little pigment to it and dab it on the icing.

For beautiful blending, use the wet-on-wet technique (see page 9). Let the individual colour surfaces dry out to prevent the different elements from running into each other.

SWISS CHEESE PLANT

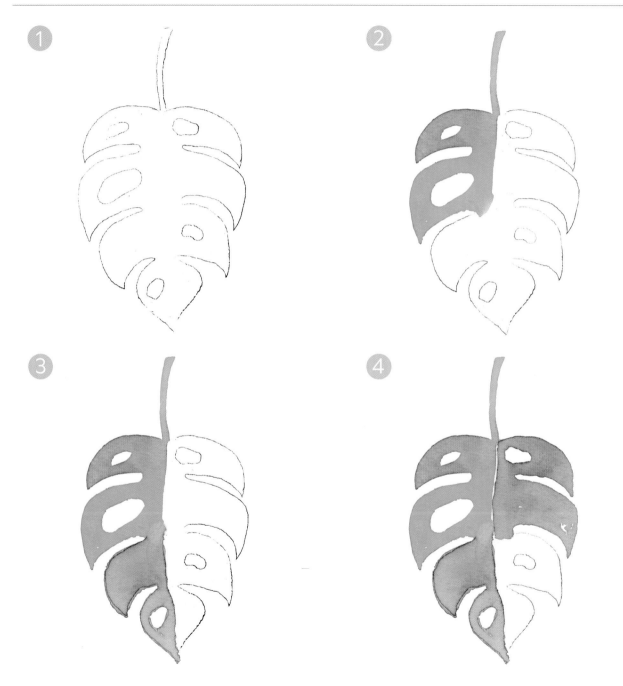

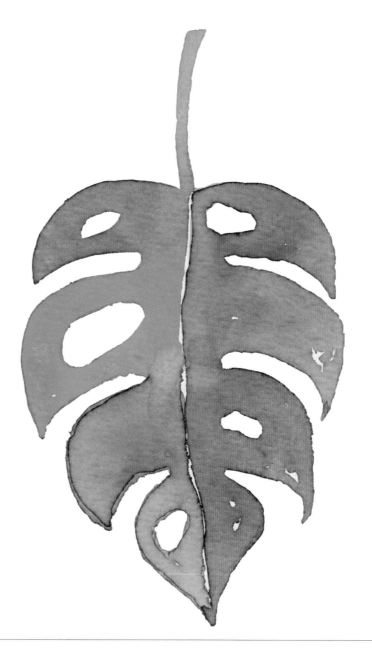

GOOD TO KNOW: Here it is best if you work on the leaf in quarters. Dampen the leaf first with water and then fill in the first quarter with a shade of green. As long as it remains wet, you can add some different green hues to it – this will result in a wonderful composition.

Go around the holes of the Swiss cheese plant with a fine brush and water. This way, you will avoid the spaces being filled with paint by accident, as the paint will only run along the dampened areas.

AVOCADO

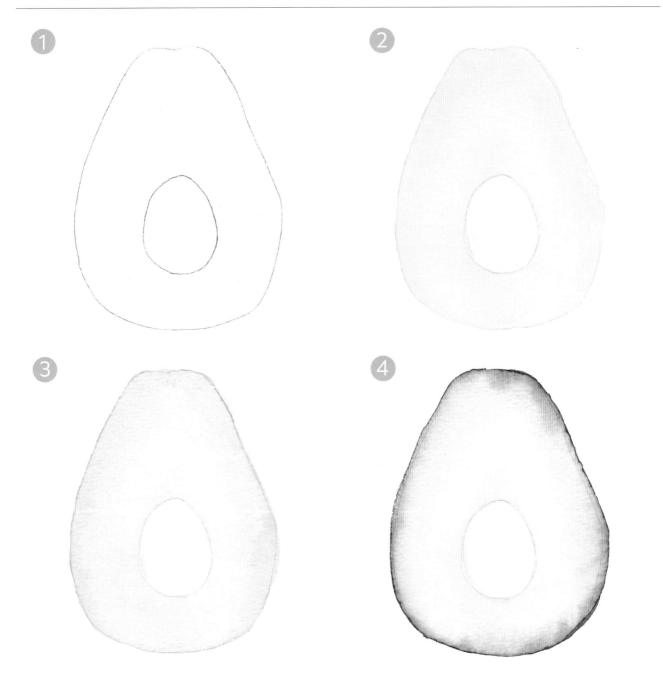

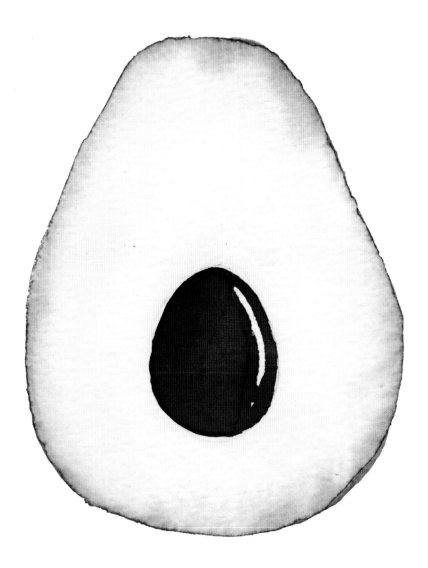

GOOD TO KNOW: Paint the layers for the flesh and the skin of the avocado using the wet-on-wet technique (see page 9). For the green outer layers, dab some green along the edge and let the colours flow together naturally. Fill in the stone of the avocado at the last step, with a shade of brown, when the rest of the motif is completely dry.

HEART CACTUS

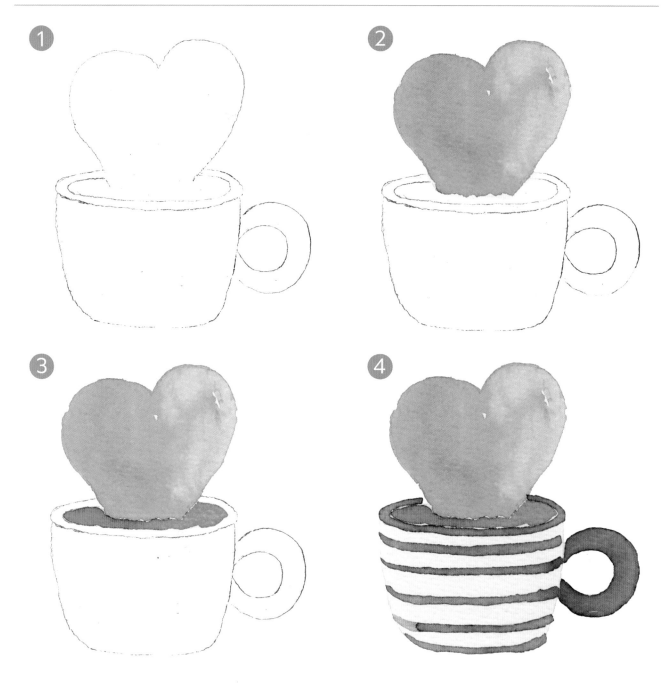

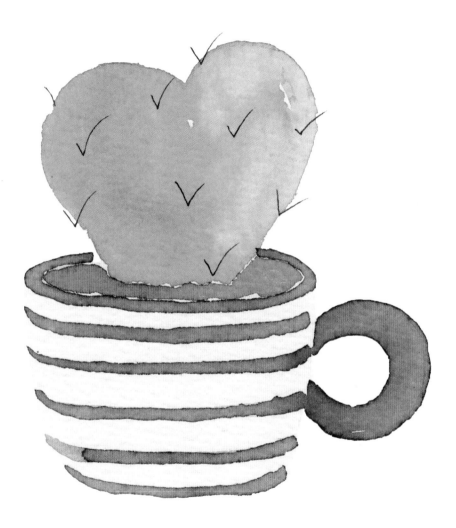

GOOD TO KNOW: The pot gets its rounded shape from the blue horizontal stripes. Curve the lines at the end to give a feeling of form. Let each layer of paint dry before you continue with the next colour.

ANEMONE

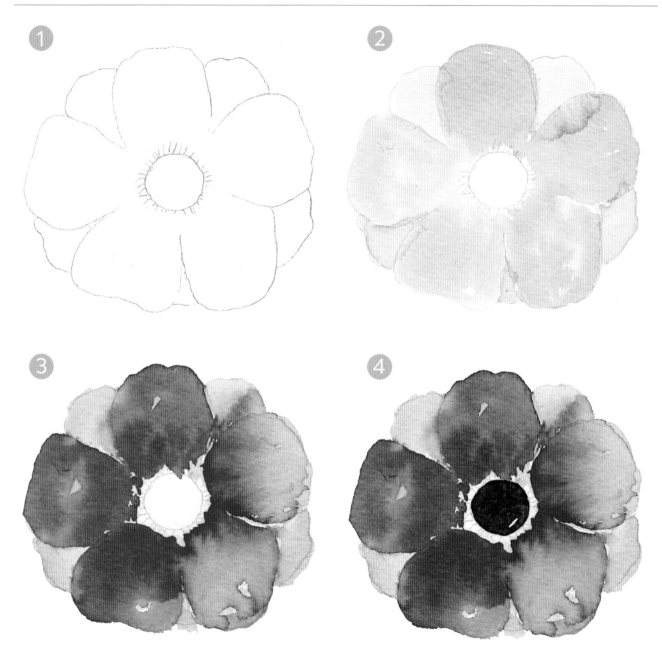

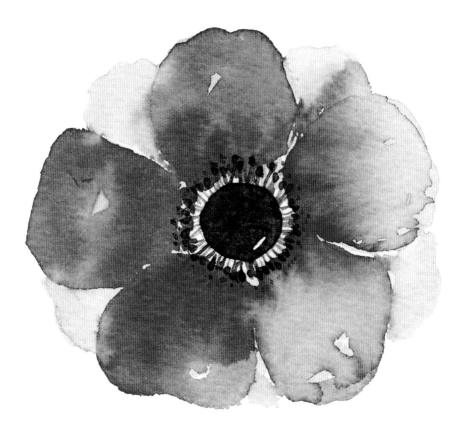

GOOD TO KNOW: For the colour blending on the foremost petals, keep adding stronger hues to the first, very dilute, light purple layer, preferably when it is wet.

Fill in the stamens in the middle with black paint only when the petals are completely dry.

WILLOW BRANCH

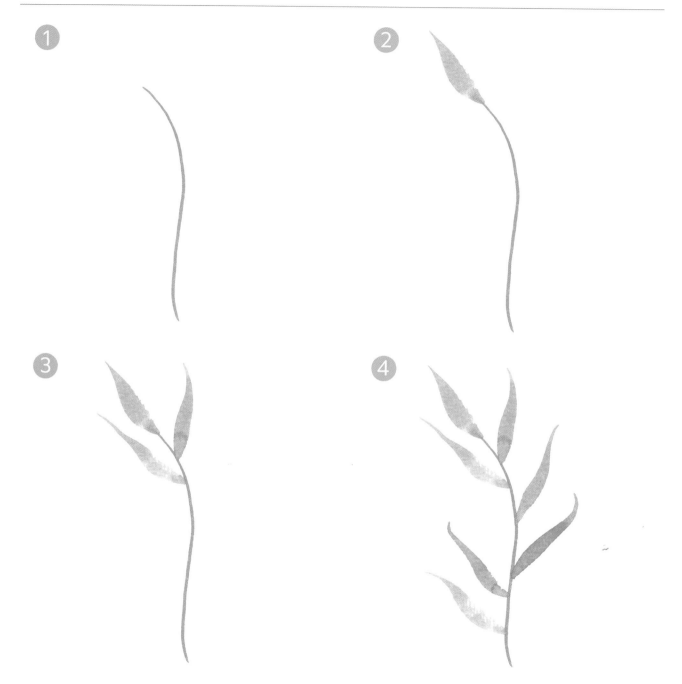

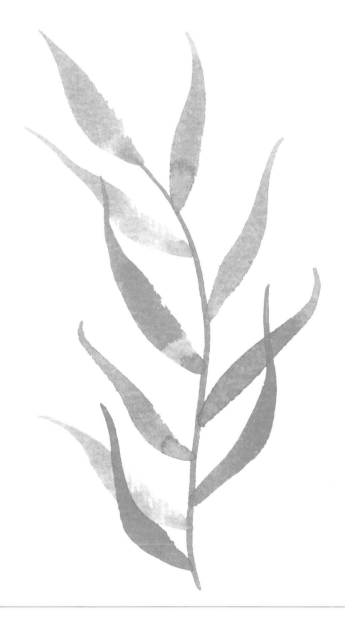

GOOD TO KNOW: On this branch, you can see that some leaves are overlapping. This creates a sense of depth and is achieved by making the leaves underneath a little lighter, using more water than for the leaves on the top. Paint on the second layer only when the first layer is dry. You can find tips on painting leaves with single brushstrokes on page 7.

ICE CREAM

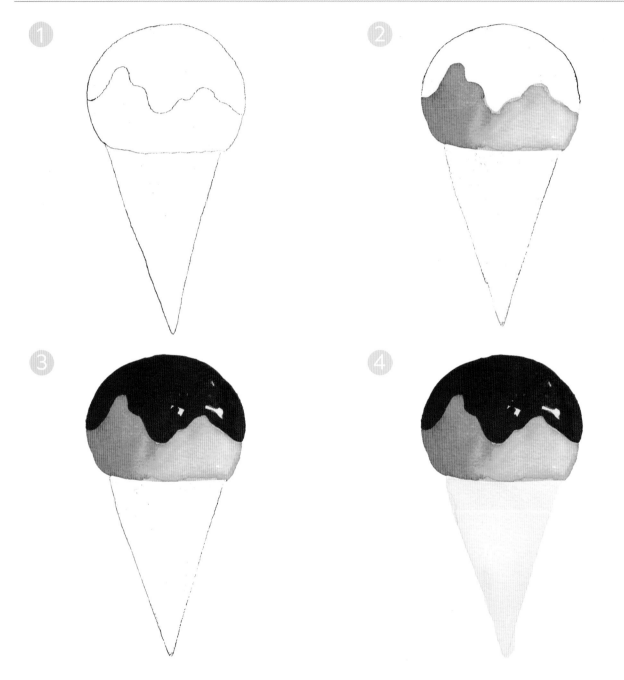

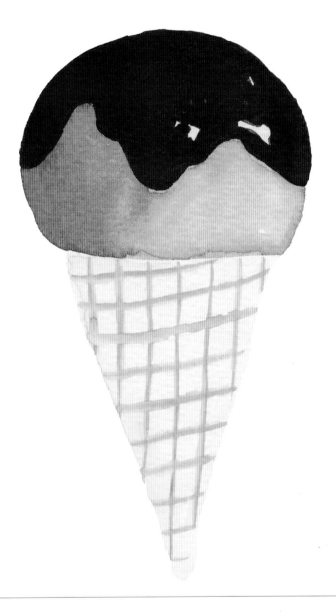

GOOD TO KNOW: For the chocolate coating on the ice cream, mix some brown with a little black. This turns milk chocolate into dark chocolate in no time at all.

Each individual layer must be dry before you continue with the next.

LLAMA

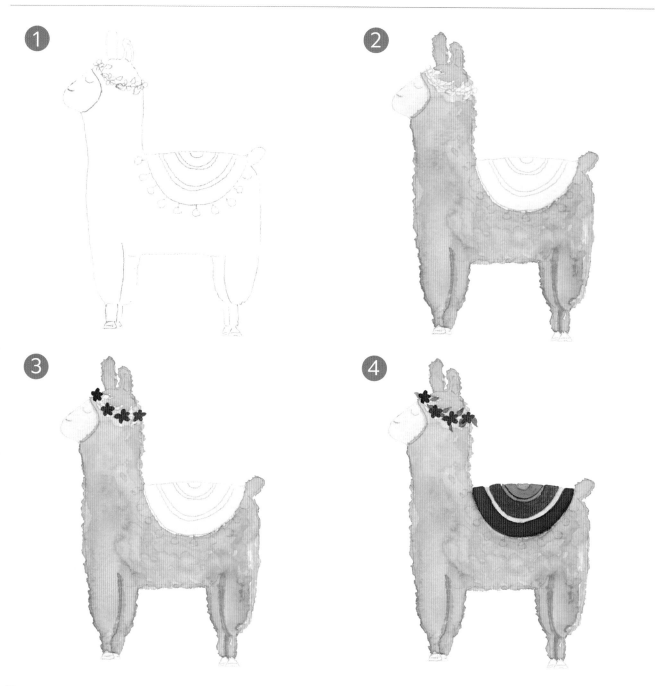

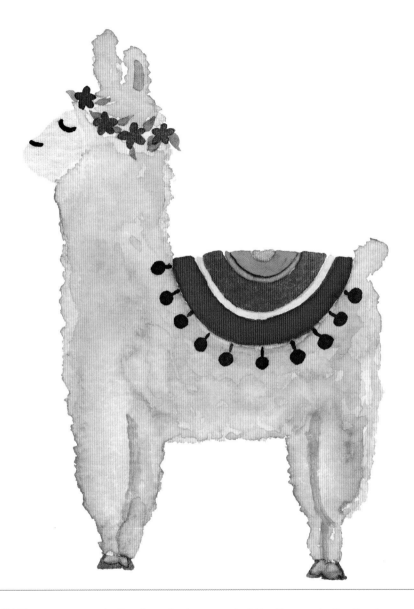

GOOD TO KNOW: You can create the llama's shaggy coat by dabbing along the edge of the subject with your brush. The face, however, has a different fur structure, which can be distinguished using a softer hue.

Let the flowers in the floral crown dry out before you fill in the leaves – do the same with the individual colours of the blanket.

SNAKE PLANT

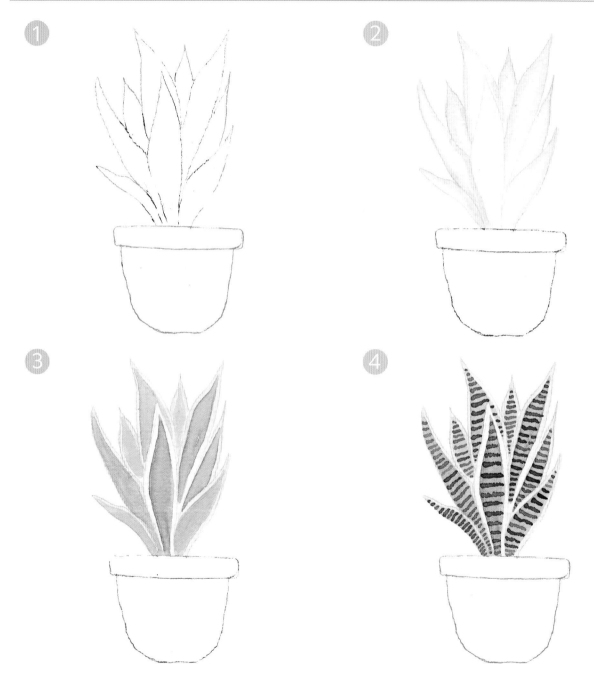

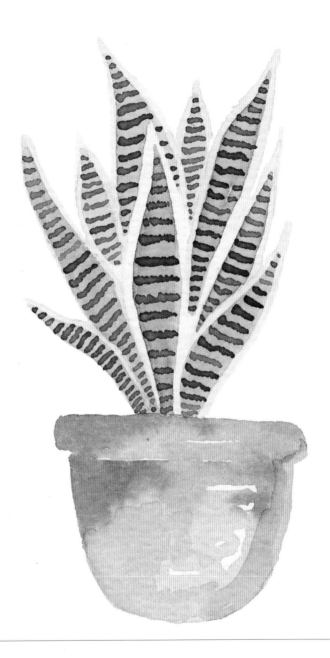

GOOD TO KNOW: The shade of yellow with which you start the snake plant will later form the edges of the leaves and remain visible. You can achieve a more dynamic effect by applying the dark green stripes in a slightly jagged pattern. White areas and lighter parts on the plant pot create additional energy and an interplay between light and shade. Apply each layer of colour only when the previous one is dry.

ROSEBUD

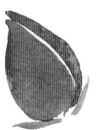

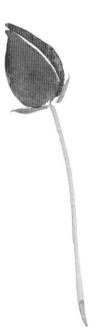

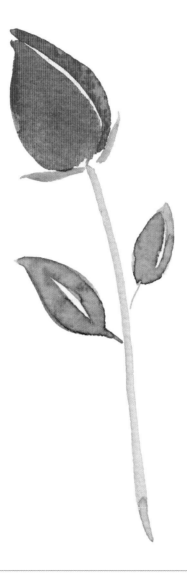

GOOD TO KNOW: Be careful to leave a fine white space between the larger part of the flower and the thinner stripe on the right of the rosebud (see steps 1 and 2). This is what makes the bud recognizable.

Add the stem and the leaves when the bud is dry to avoid the colours blending. You can practise painting the individual leaves first (see 'Spring Leaf', pages 42–43).

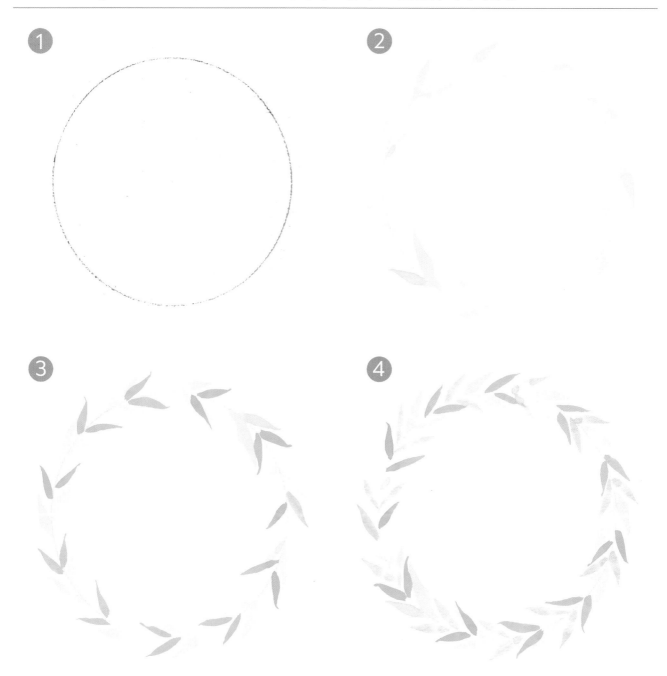

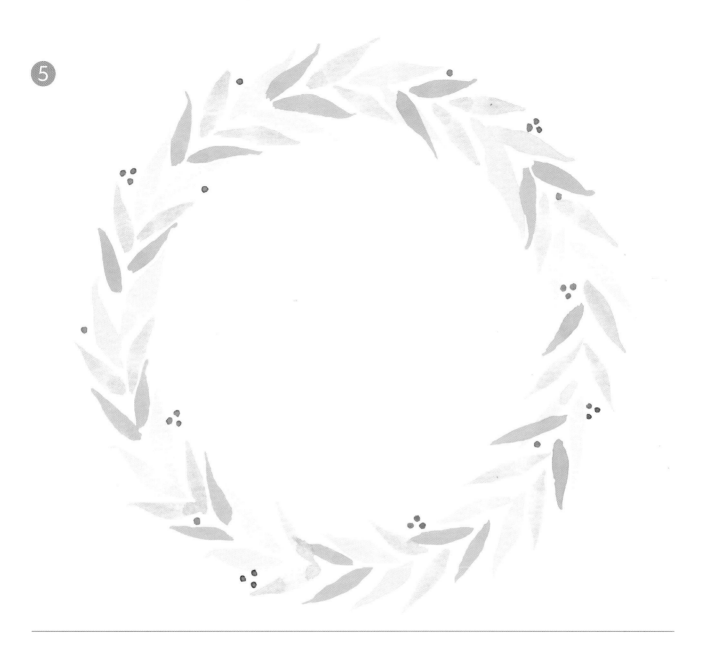

GOOD TO KNOW: With this wreath, it is important to let the individual layers dry before you add the different colour elements. Distribute the elements fairly evenly around the circle to create a more harmonious effect.

Use a pair of compasses or a small bowl to help you draw a circle as a guide for the wreath. You can find tips on how to hold the brush for the leaves used here, on page 7.

STRAWBERRY

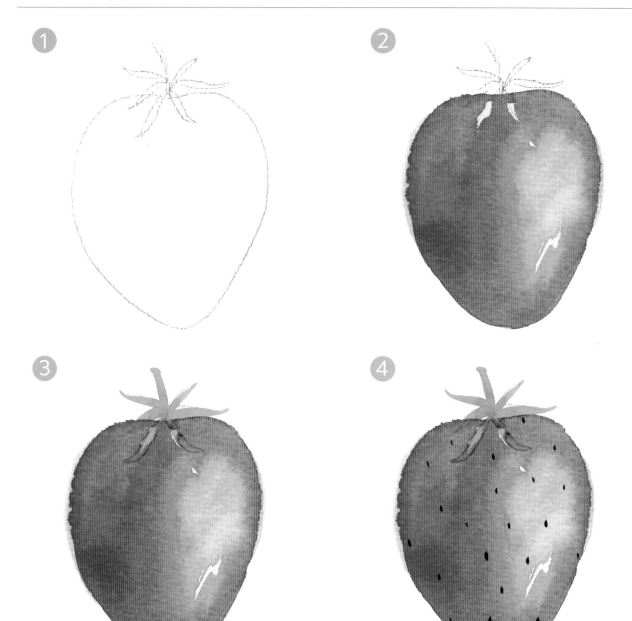

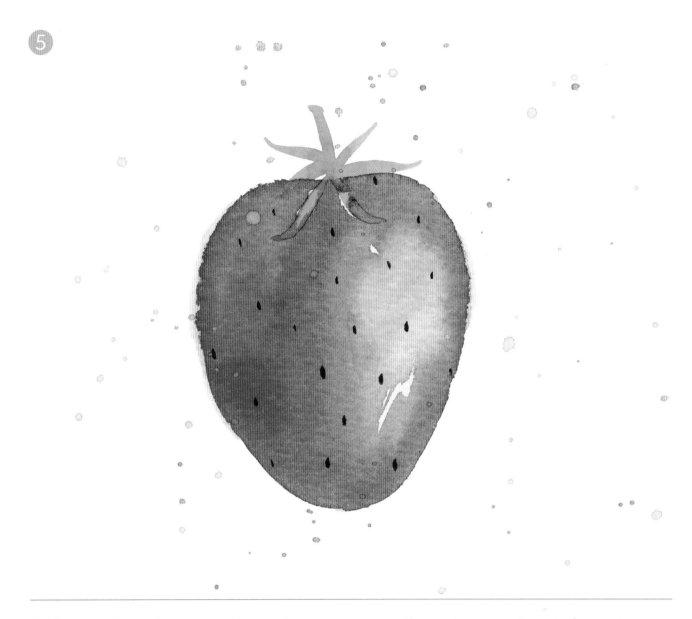

GOOD TO KNOW: You can draw this strawberry without using outlines, but if you prefer, draw a rough sketch. You can see in this motif how an object can be depicted with little effort. It does not even have to look realistic: if you include some distinctive features in your subject, it will be instantly recognizable. I want to encourage you, to help you lose any fear of the blank paper and to trust yourself just to go for it!

FLOWER

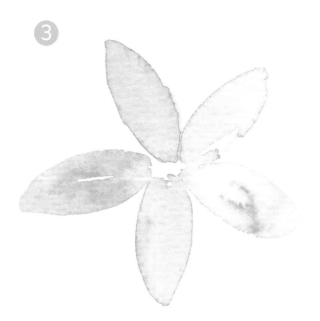

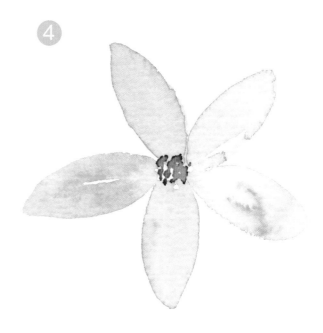

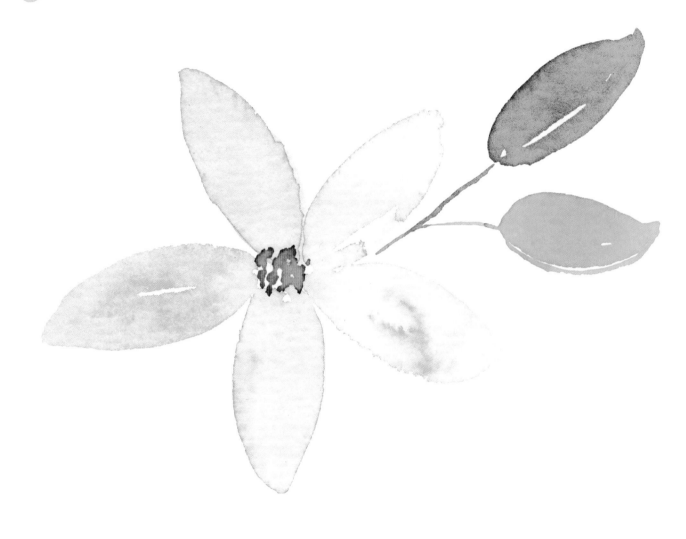

GOOD TO KNOW: For the petals, first draw the shape and then load some water onto the brush. Pull in the colour from the outer edge towards the centre of each petal, distributing the colour (see 'Washes/Wet-on-wet' on page 9). Add the stamens and leaves when the petals are dry. You can practise painting the leaves on their own on pages 42–43 ('Spring Leaf').

FLAMINGO

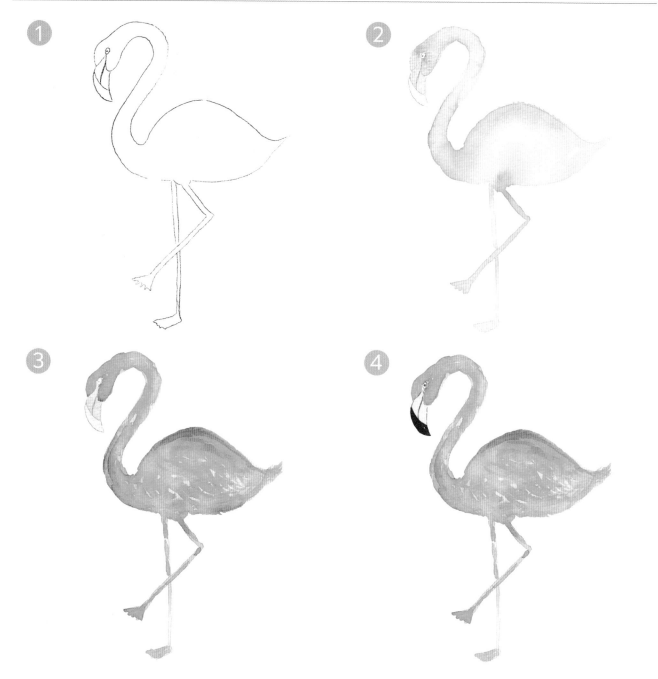

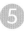

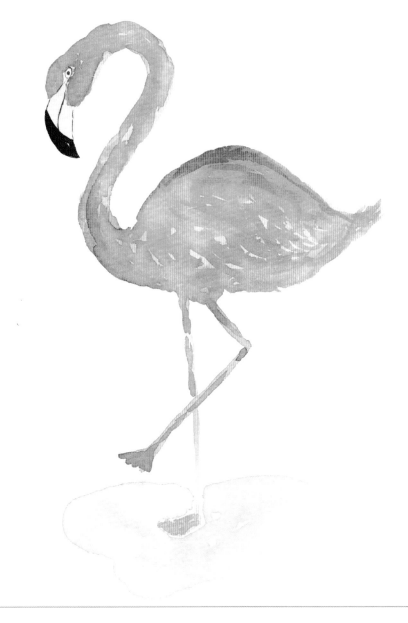

The flamingo has a soft pink plumage, so you should work with a lot of water or a pre-mixed shade of pink. Paint the feathers on the dried-out layer with irregular strokes and in a somewhat more vibrant hue. The legs can be painted in an even stronger pink – or you can mix in a light grey. Since details give your picture a more dynamic effect, you can always consider adding little things into the motif – here, for example, the puddle.

SPRING LEAF

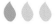

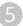

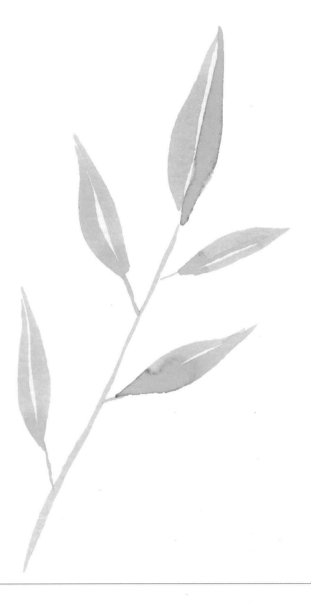

GOOD TO KNOW: Leaves like these are formed from only two brushstrokes. The white space in the middle can create the impression of a reflection – however, you can put this anywhere you like on the leaf. You can find more about holding the brush when painting pointed leaves on page 7.

DELICATE SUCCULENT

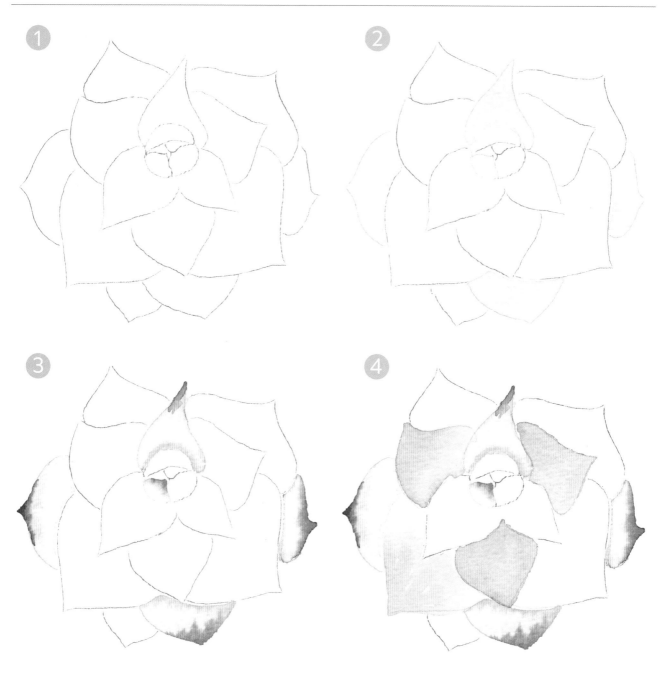

⑤

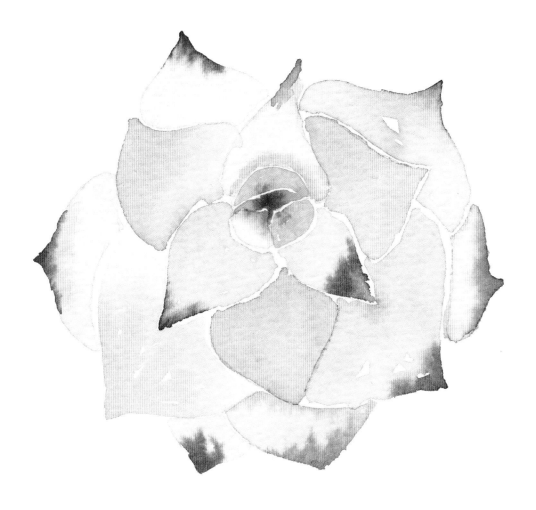

GOOD TO KNOW: To start with, work on the leaves that are not touching, and continue only when they have dried. Leave some white spaces between the leaves – this will help to make the shape of the plant recognizable.

Work towards the centre with stronger colours. This is where the least light reaches, which makes the plant look darker inside.

SPRIG OF ELDER

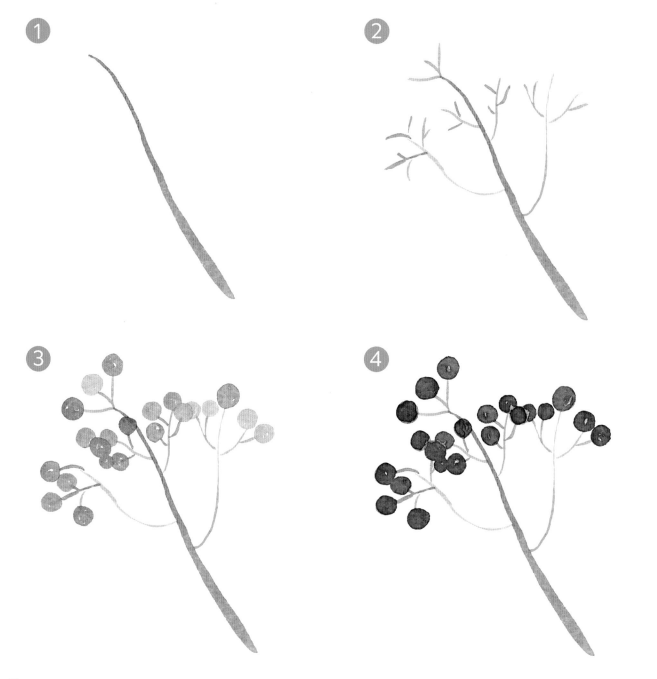

5

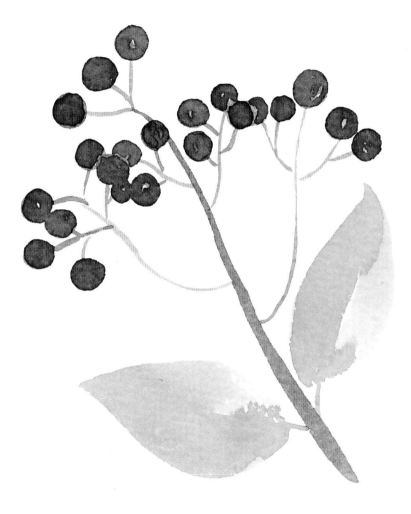

GOOD TO KNOW: Paint the berries of the elder sprig first with a soft shade and then go over them with a darker blue-purple. Let the lighter layer of colour shine through a little by not covering the berries completely with the second layer.

For the composition of the twig and the berries, you can have a look at some photographs of real elderberries online. If you want to practise painting the leaves on their own, go back to pages 42–43 ('Spring Leaf').

ICE LOLLY

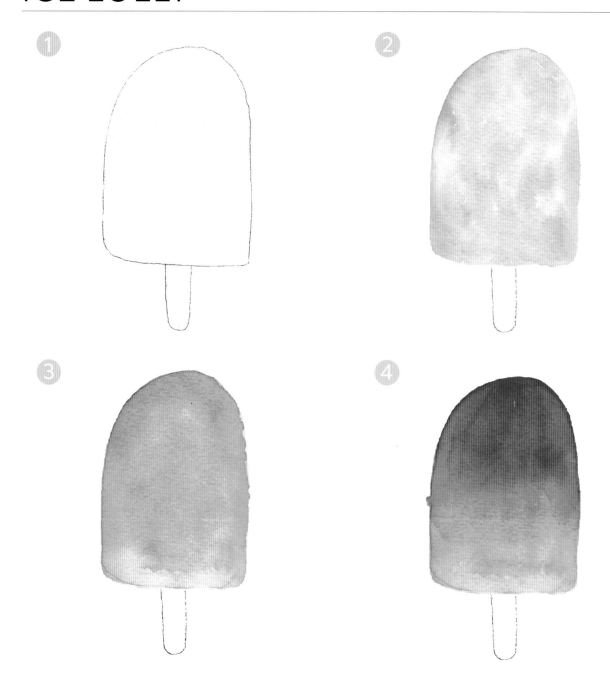

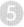

GOOD TO KNOW: Pulling down the colour from the top to the bottom of the lolly will give it a wonderful colour gradation. Use different shades of one or two hues of pink and let these blend together on damp paper. You can paint in the stick when the lolly is dry.

49

FLOWERING CACTUS

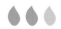

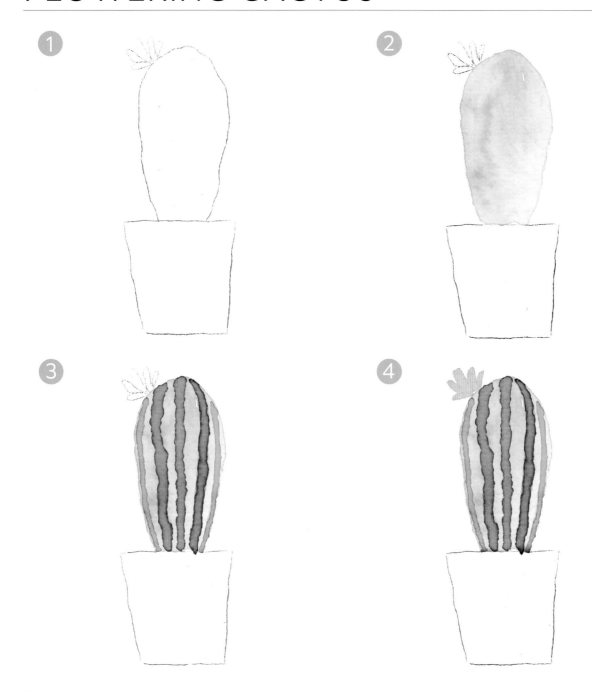

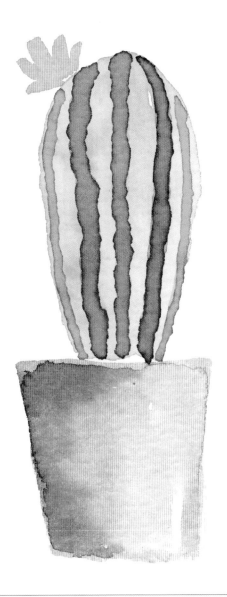

GOOD TO KNOW: Here, you need to let the layers of paint dry before you carry on with the next colour. To give your pot a lovely colour gradation, however, I recommend the wet-on-wet technique (see page 9). Individual areas left white work as reflections and create some additional interest for your flowering cactus.

FESTIVE LEAF WREATH

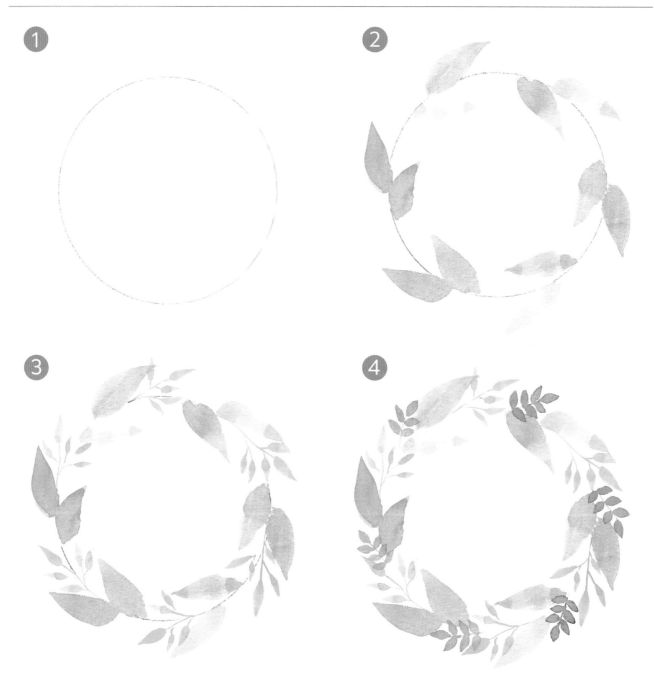

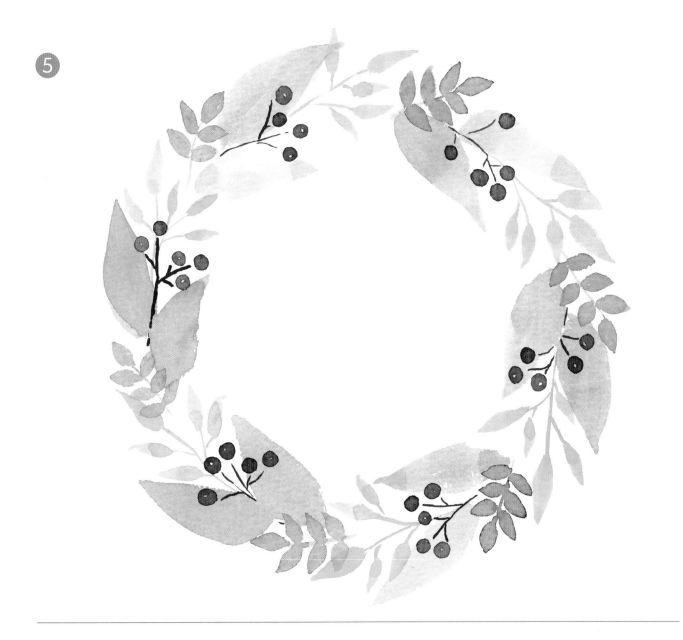

GOOD TO KNOW: Distribute the different leaves evenly around the circle to create a harmonious picture. Let each layer dry before you continue with the next.

If you want to give your wreath an autumnal or Christmassy feel, simply change the colours of the leaves and other elements. You can practise painting the individual leaves on pages 42–43 ('Spring Leaf').

ROSE

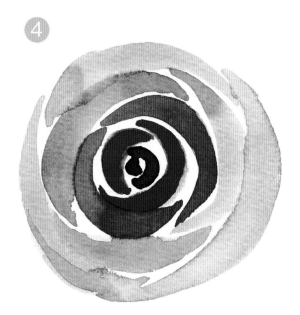

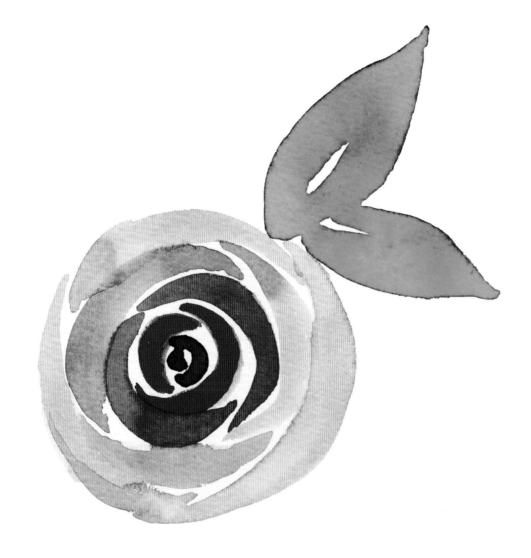

GOOD TO KNOW: First, load plenty of paint onto the brush so that you can paint the centre with just a few strokes. Wash the brush out a little and paint in some more layers of petals. Make sure that the brush is not too wet, otherwise the water will stay on the paper. You can always test the shades on some scrap paper. Continue until the outermost petals are a very dilute shade. You can practise painting the leaves on their own on pages 42–43 ('Spring Leaf').

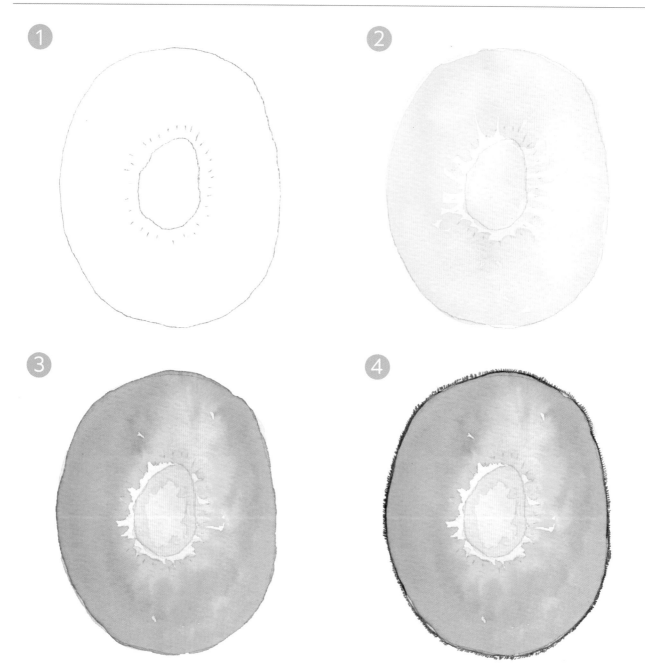

5

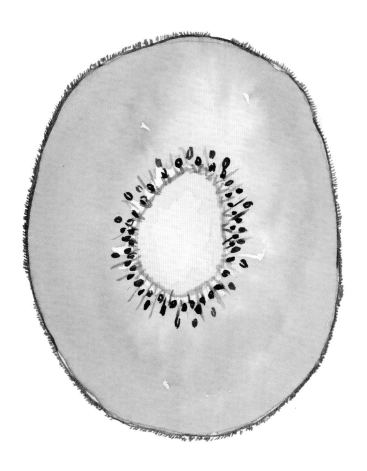

GOOD TO KNOW: Begin with a light yellow and paint a green layer on top using the wet-on-wet technique (see page 9). This should still allow the yellow to shine through. You can paint the fine hairs of the kiwi fruit peel and the small seeds inside the fruit with a very fine brush when the green has dried.

WHALE

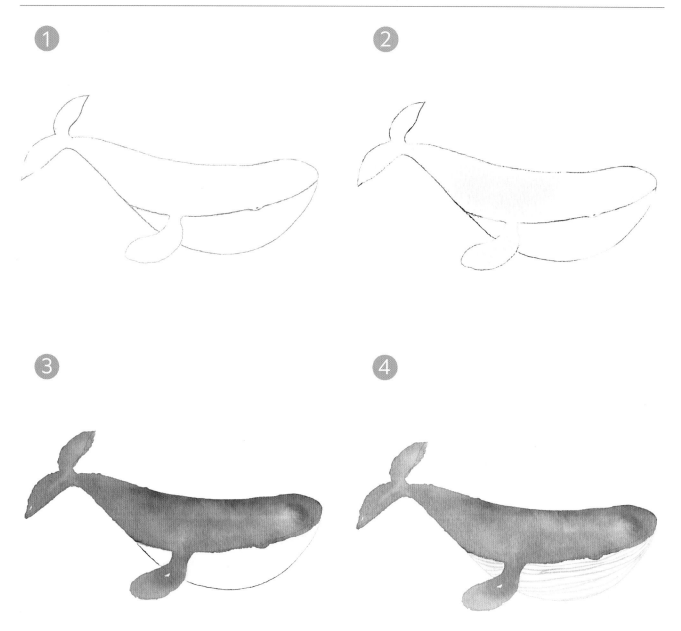

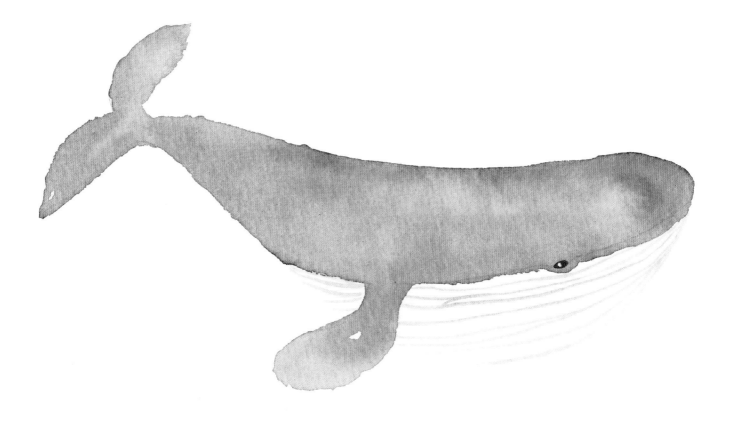

GOOD TO KNOW: Here, you are working with the wet-on-wet technique again (see page 9). Gradually add various pre-mixed shades of blue to the motif – the colours will continue to spread out for a while after you have stopped painting. Add in the lines using a light blue-grey once the previous layers have dried. Using a white gel pen, draw a small spot in the middle of the black eye to bring your whale to life.

59

HIBISCUS

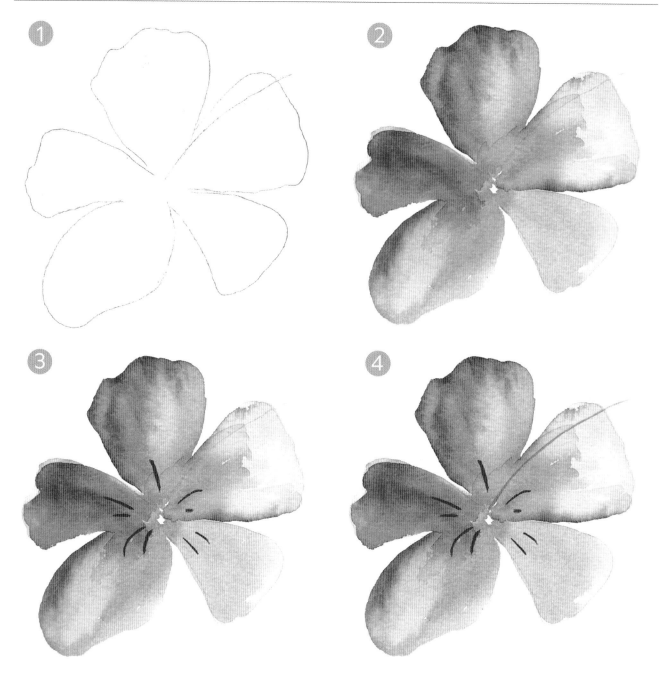

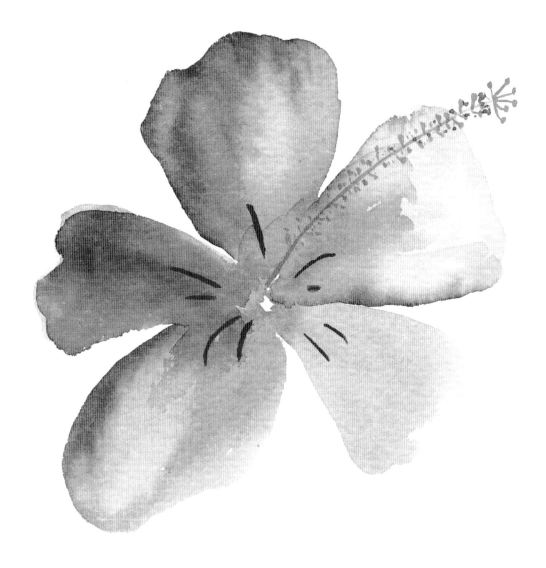

GOOD TO KNOW: To create the shading on the petals, use a soft pink hue. While the paper is still damp, dab a slightly stronger colour in some selected areas.

You can experiment until you are happy with the different nuances. Give the colours time to develop. Add the details when the petals are dry.

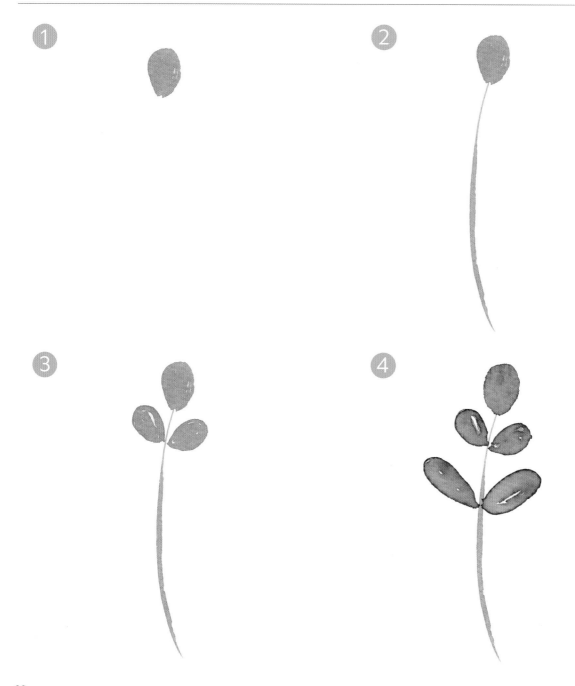

5

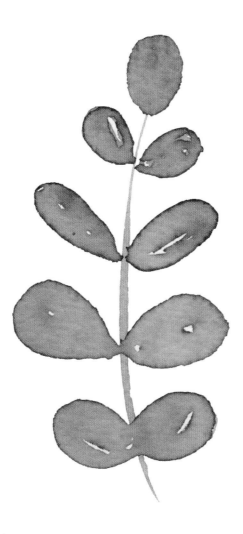

GOOD TO KNOW: First paint the shape of the leaves, then load some water onto the brush and pull in the colour over the leaf (see 'Washes/Wet-on-wet', page 9). Leave some areas white to suggest reflections. You can set the leaves opposite each other or alternate them – test out both ideas to see which you prefer.

63

FLORAL WREATH

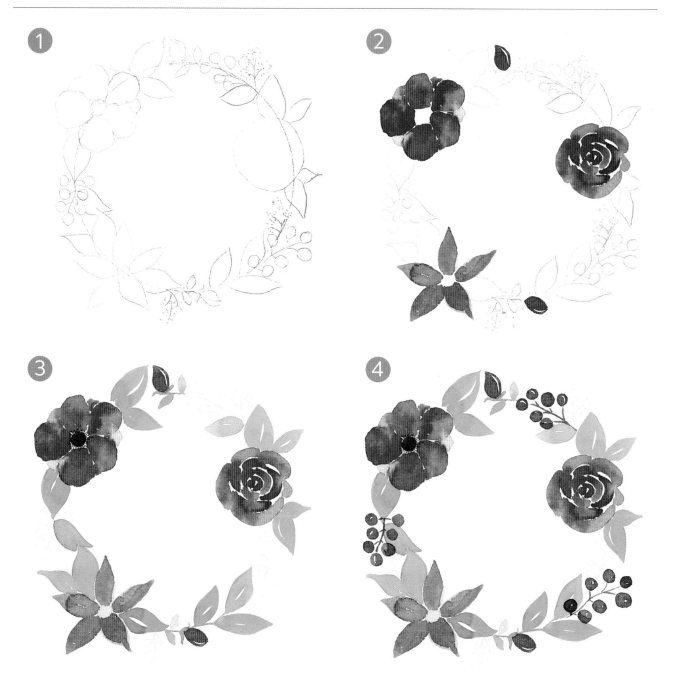

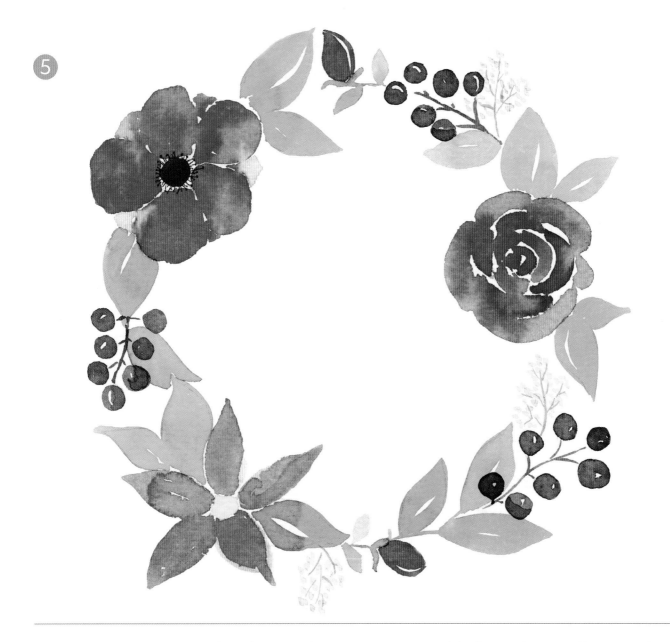

GOOD TO KNOW: For complex subjects such as this wreath, a preliminary sketch will help you achieve balance in the picture. Do not press too hard on the pencil, so that you can rub the lines out later without damaging the texture of the paper. Pay attention to the arrangement of the flowers, leaves and berries so that the composition is evenly balanced. First paint the larger elements, like the flowers, then the leaves and finally the berries. Practise the individual elements on pages 22–23, 32–33, 38–39, 42–43, 46–47 and 54–55.

FERN

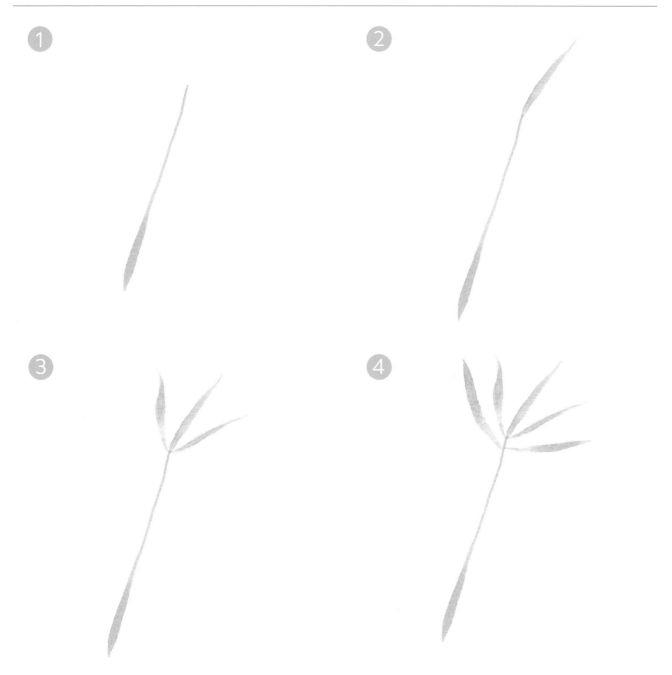

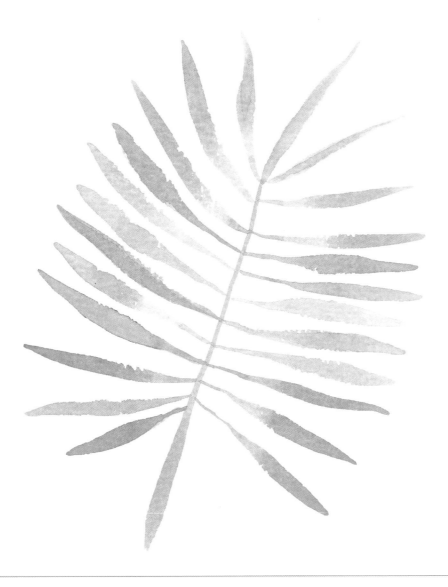

GOOD TO KNOW: Work mostly with the tip of the brush for this motif, and pay attention to how much pressure you apply. For more advice, you can refer back to page 7.

DESERT CACTUS

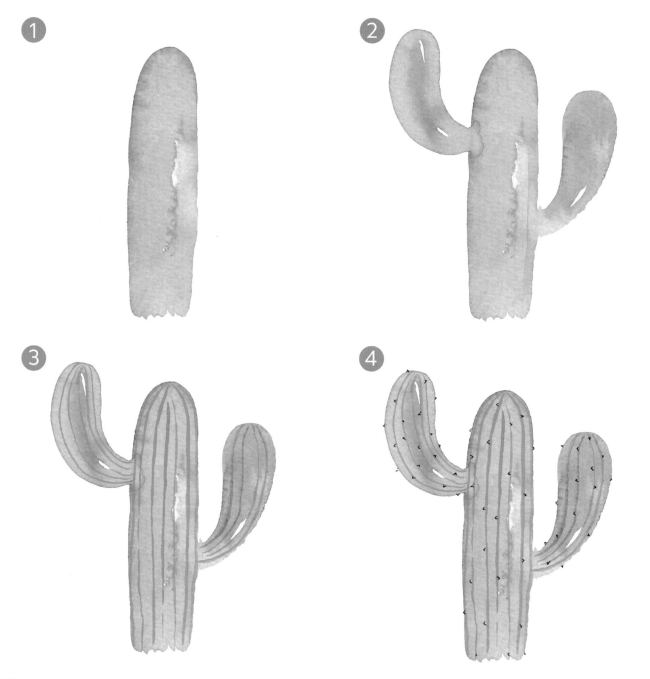

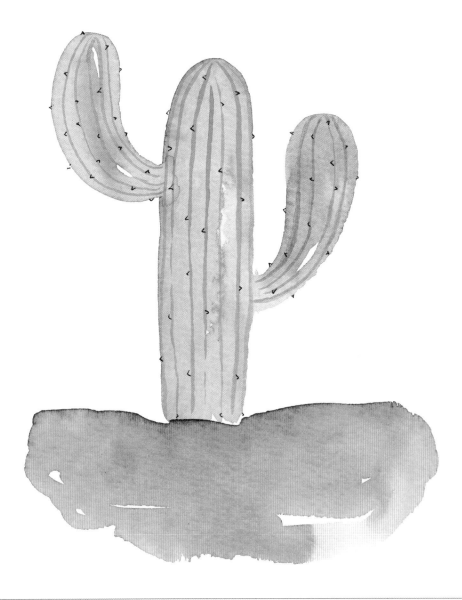

GOOD TO KNOW: Draw in the vertical stripes of the cactus with a very fine brush only when the previous layers are completely dry. The same applies to the black needles. You can draw these in using a fineliner instead of a brush. Finally, you can complete the motif with a detail, such as adding a sandy base to the cactus.

TOUCAN

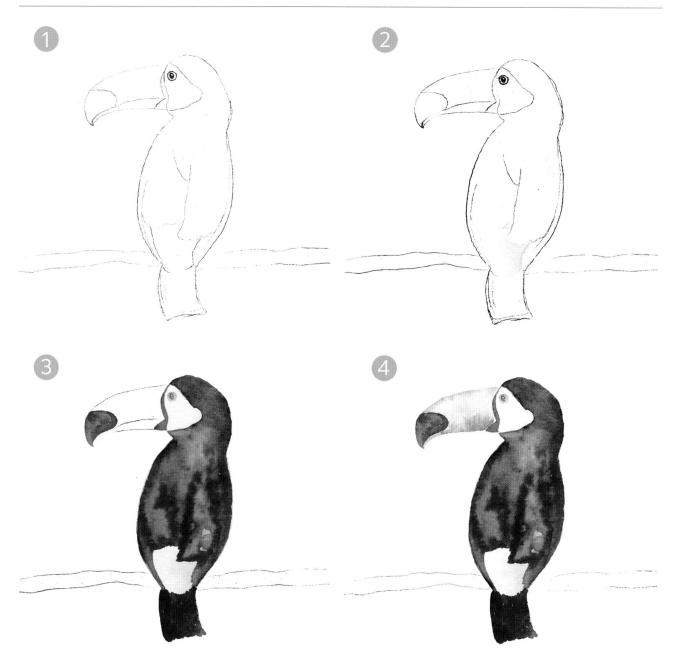

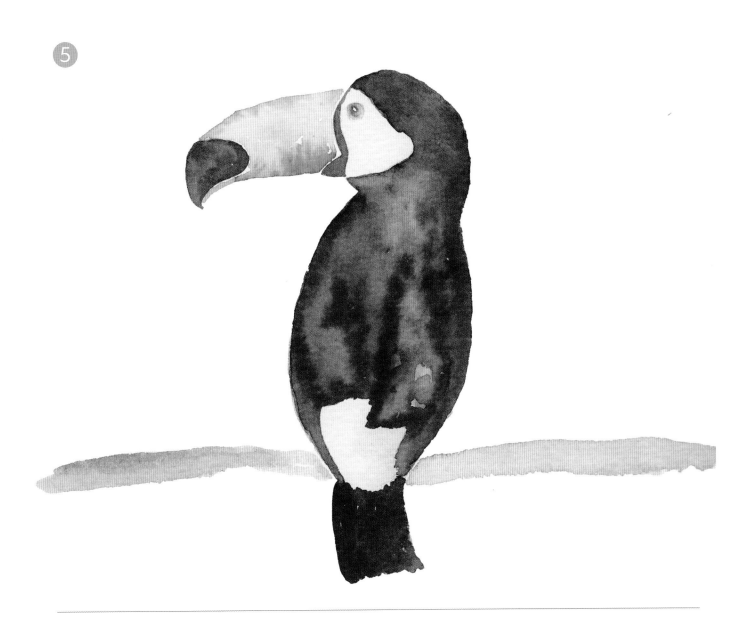

GOOD TO KNOW: Start with the pale plumage of this tropical bird, which extends around the eyes and the throat, and hides under the wing. You can achieve the pale effect with a very dilute black.

For plumage, it is best to use the wet-on-wet technique (see page 9) and add the beak and the branch only when the other colours have dried.

BANANA LEAF

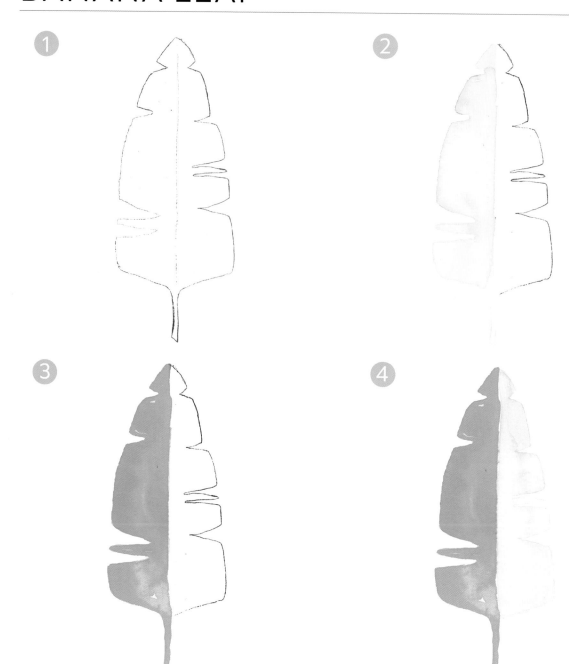

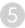

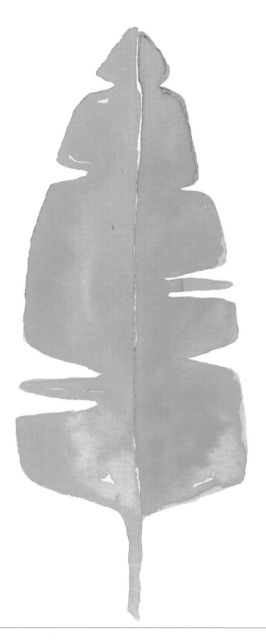

SOFT ICE CREAM

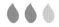

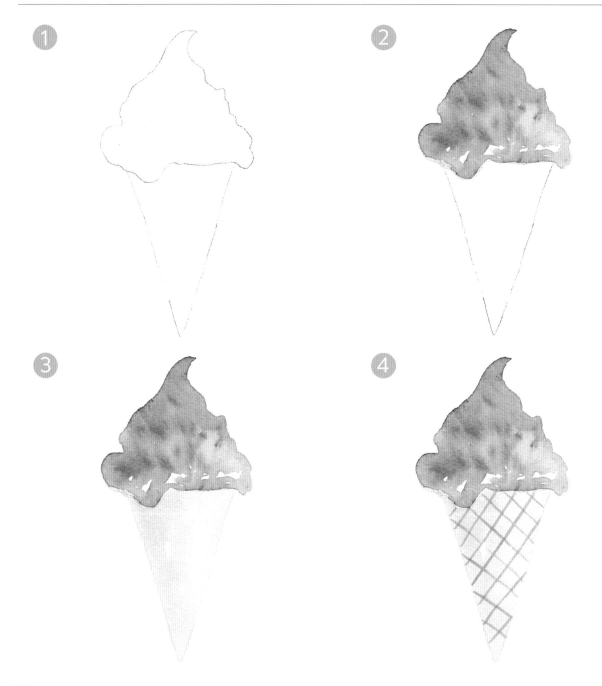

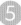

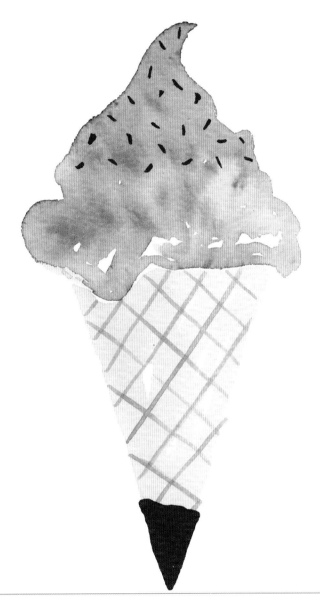

GOOD TO KNOW: Let the individual layers dry between painting the ice cream, the cone and the chocolate tip. Use the wet-on-wet technique (see page 9) for the ice cream.

A few strong, accented colours on the light background can represent blueberries or chocolate chips in the ice cream itself.

TROPICAL WREATH

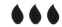

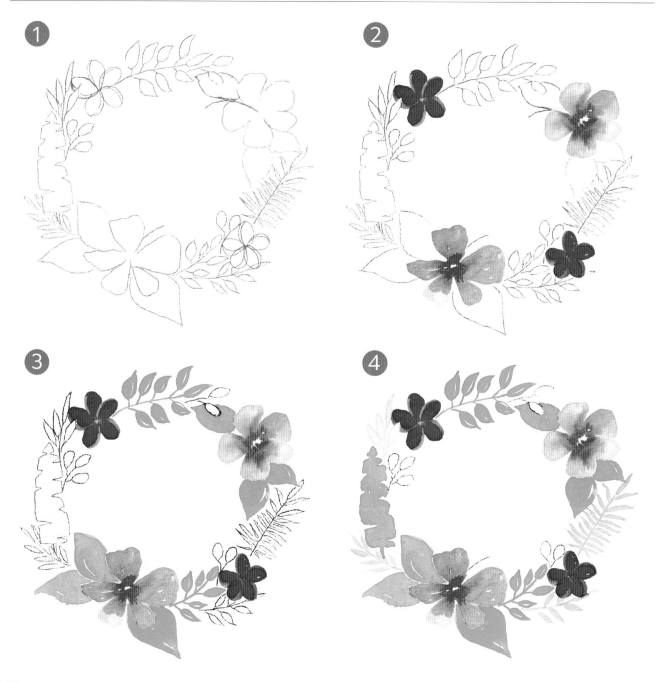

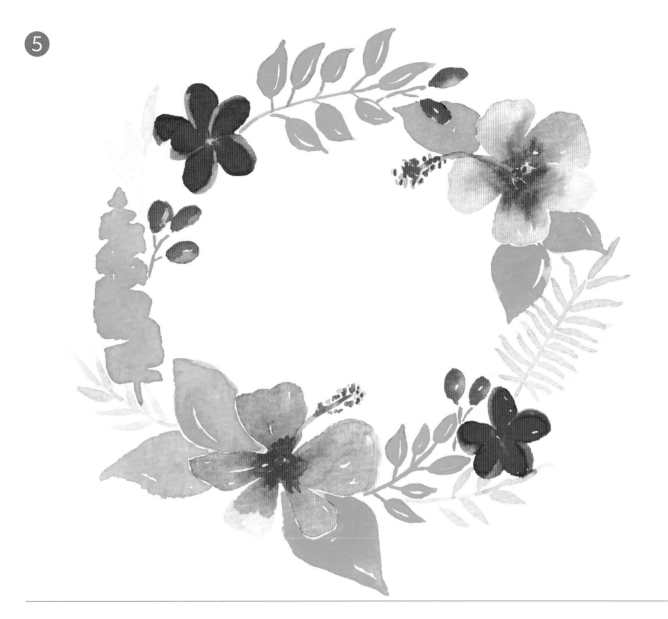

⑤

GOOD TO KNOW: Build up your floral wreath gradually. Begin with the larger elements – such as the flowers – and then add in the leaves and other elements. In this tropical version, you can see some of the individual motifs already covered in this book. You can practise the hibiscus on pages 60–61, the fern on pages 66–67 and the banana leaf on pages 72–73.

EUCALYPTUS

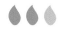

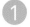

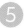

ORANGE

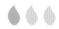

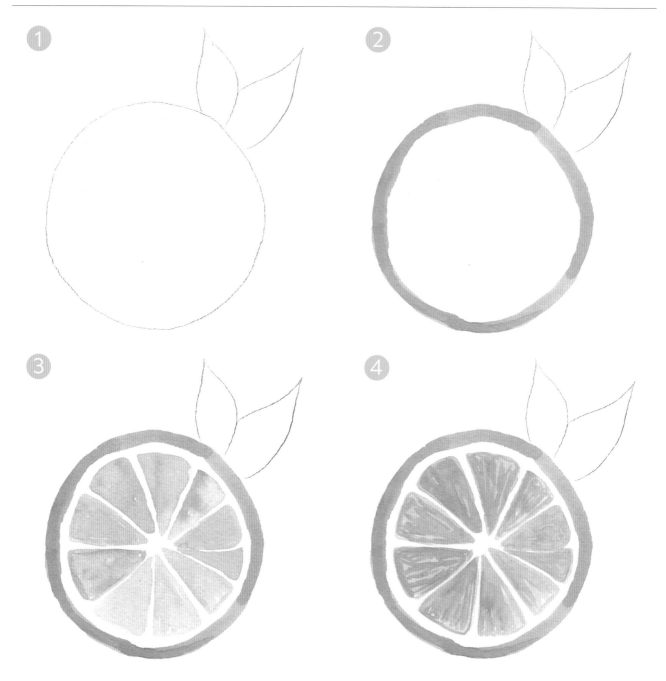

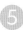

GOOD TO KNOW: This is a wonderful study for the lemon on pages 88–89. To make the flesh seem more realistic, use a thin brush and a brighter hue to draw fine, irregular lines.

You can practise painting the leaves on their own on pages 42–43.

POT PLANT

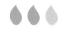

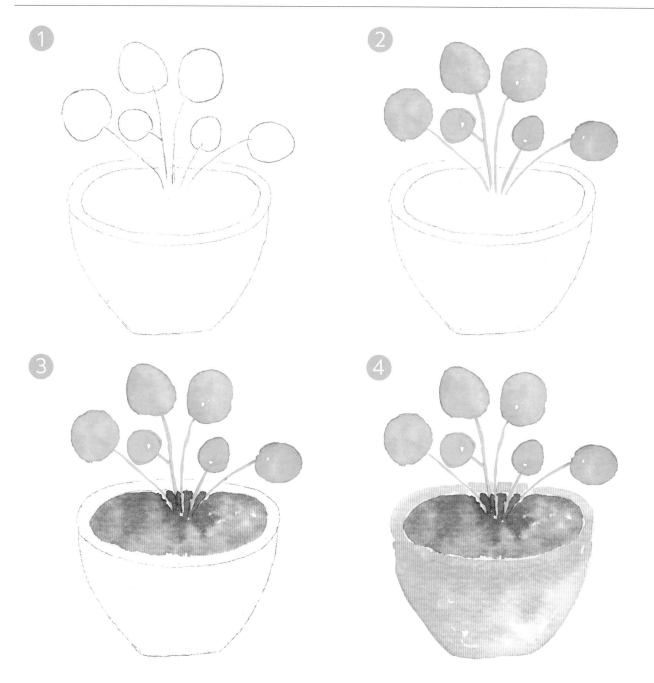

5

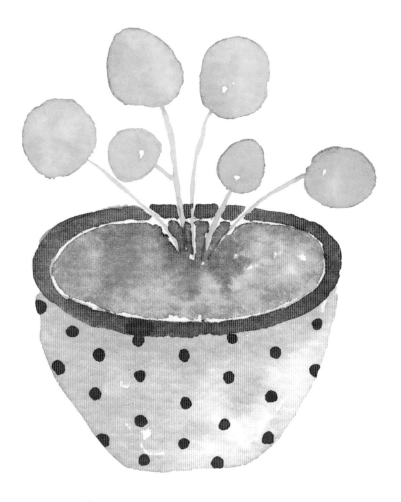

GOOD TO KNOW: To make the pot look more distinctive, the plant in this motif is kept very plain. Nonetheless, you can still give the leaves some spots of light and some structure.

You can then paint the pot with a base colour and let it dry completely. Paint around the rim and highlight the bowl with a few details like polka dots, for example.

CHOCOLATE DOUGHNUT

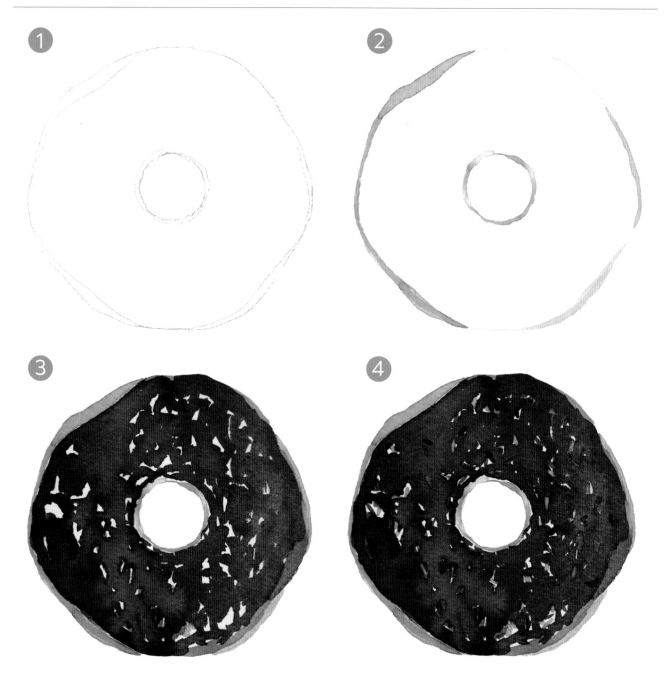

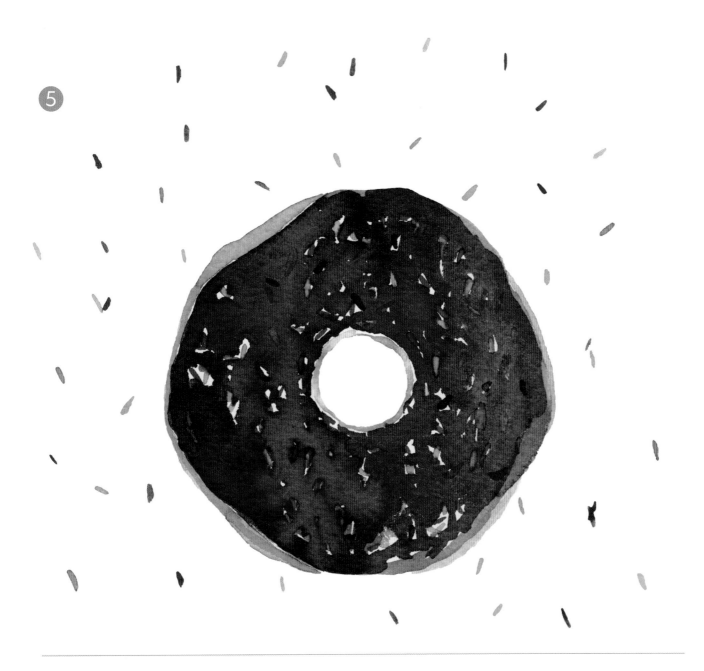

GOOD TO KNOW: You can play with different strengths of paint for the chocolate icing and so introduce a sense of light. Let each layer dry before you continue painting.

You can finish the painting with sprinkles as a detail, to create a dynamic overall picture.

PEONY

 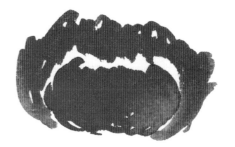

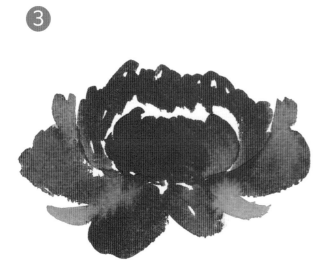

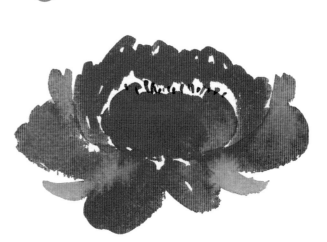

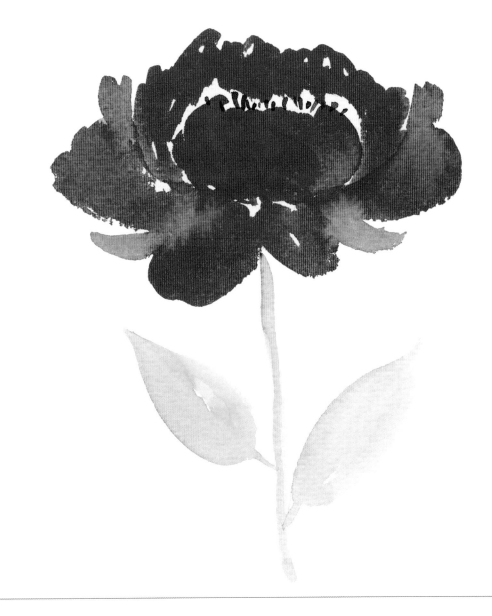

GOOD TO KNOW: You can create the characteristic appearance of the petals by painting in uneven strokes and narrow arcs. Use a more intense hue for the inside of the flower and mix this with some water for the outer petals. Occasional darker hues at the bases of the petals lend a natural effect, while white spaces give form and structure. When the petals are dry, you can paint in the stamens with fine strokes. If you want to practise painting the individual leaves, go back to pages 42–43.

LEMON

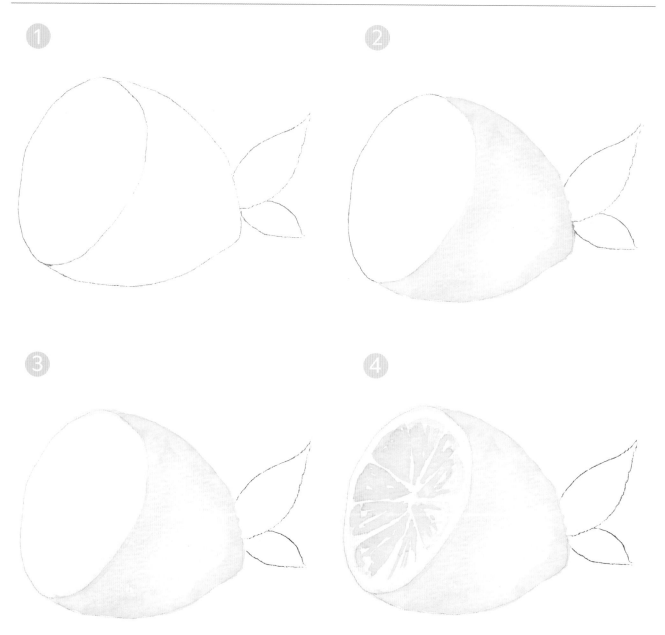

5

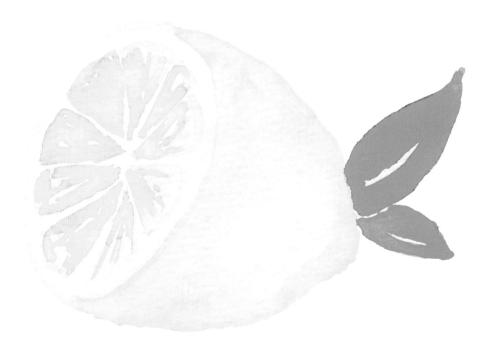

GOOD TO KNOW: If you want to practise for this motif, turn back to the orange project on pages 80–81. For the lemon flesh, paint irregular triangles which you can then draw through, unevenly, with a fine brush and paint. You can add the leaves when the yellow of the fruit is dry. You can also practise these leaves individually on pages 42–43.

FLOWER HOOP

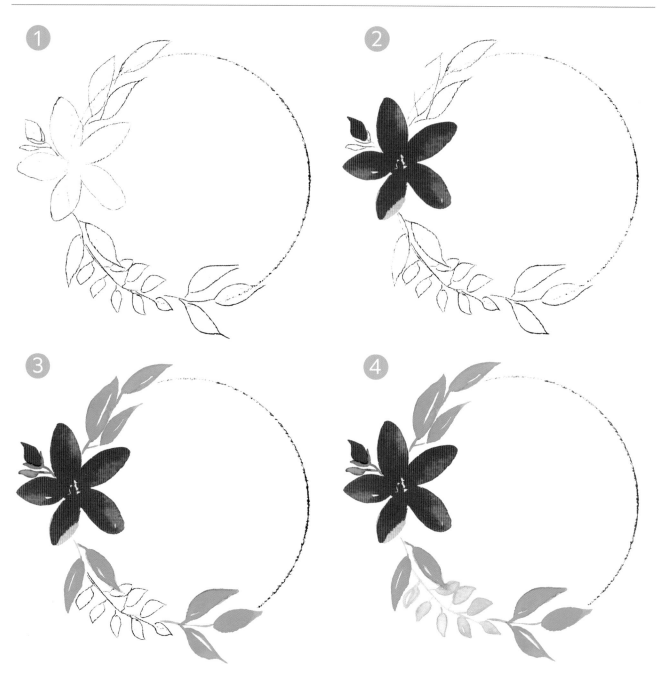

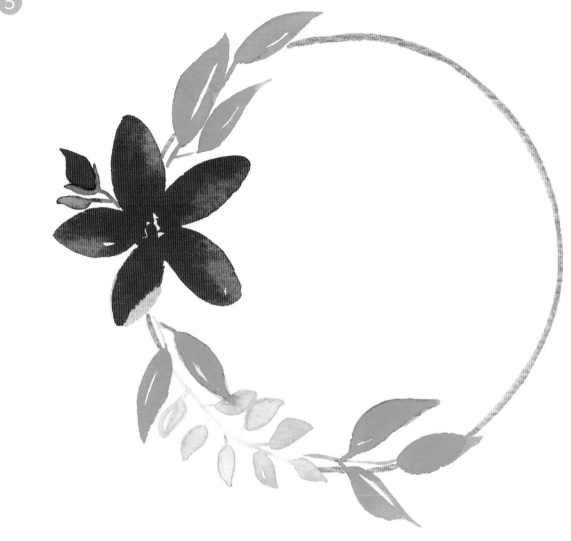

GOOD TO KNOW: It is best to decide in advance which colours you will use for this work. This way you can be sure that the whole picture will not be too gaudy. You can use a colour chart to help you: paint some small rectangles on a piece of paper in the colours you intend to use in your painting, and see how they work with each other. You can find the individual elements of this hoop on pages 32–33, 38–39 and 42–43. Advice for drawing a circle can be found on page 35.

COLOURFUL SUCCULENT

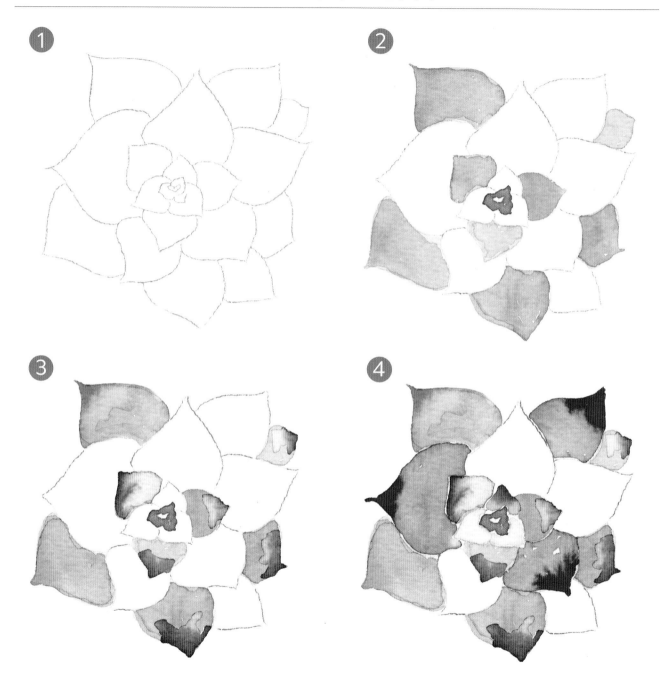

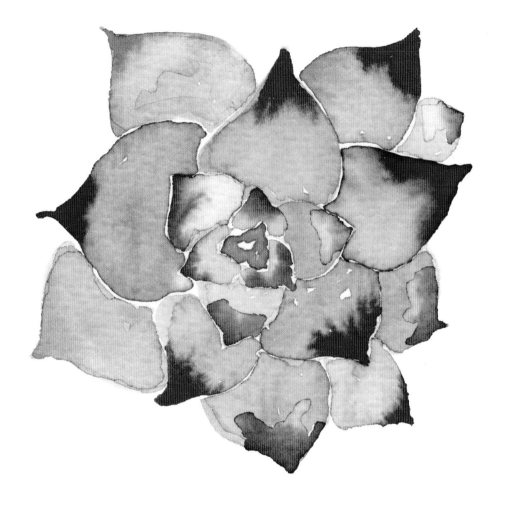

GOOD TO KNOW: If you do not want all the paint to mix together, paint only those leaves that do not touch the others, one at a time. Let the red blend in from the tips each time, using the wet-on-wet technique (see page 9). Leave white areas between some of the leaves to add more form and structure.

SPIRAL ICE CREAM

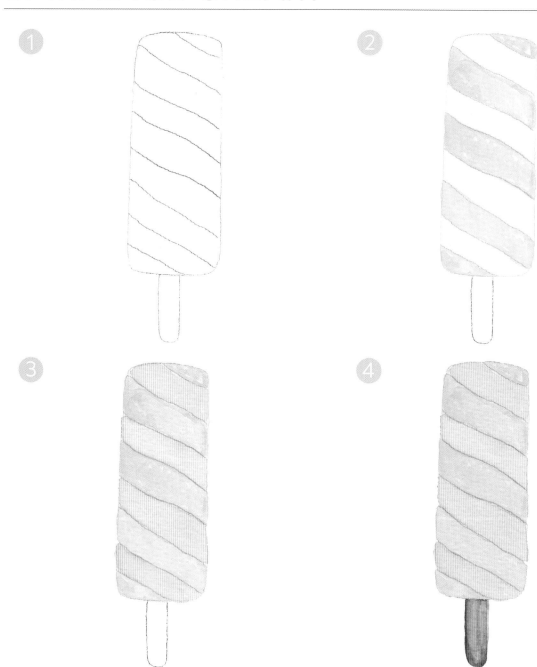

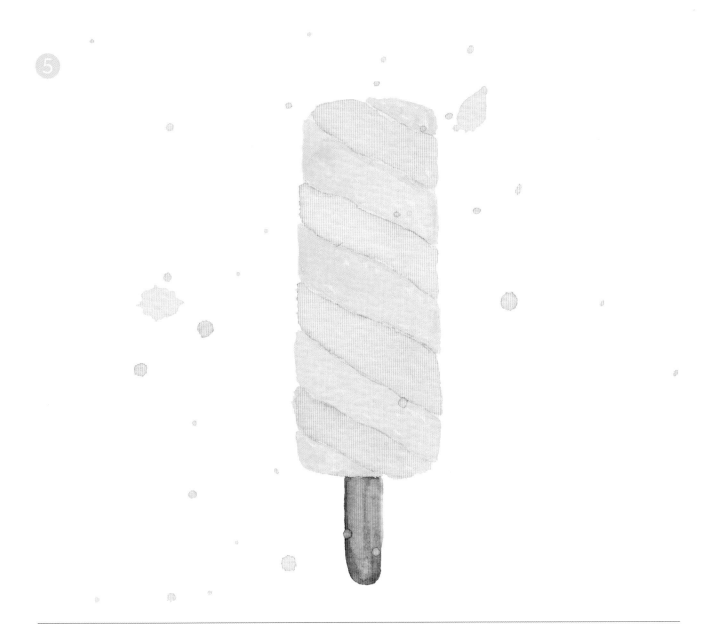

GOOD TO KNOW: Paint one spiral in a single colour first, and allow it to dry before painting the other spiral in a different colour, so that the two spirals are distinct. Paint in the stick when the ice cream is dry. You can bring a little freshness into the picture with some specks of paint. For this, take some very dilute paint and plenty of water onto the brush, hold it loosely over the picture and then tap the brush gently.

CHERRY BLOSSOM TWIG

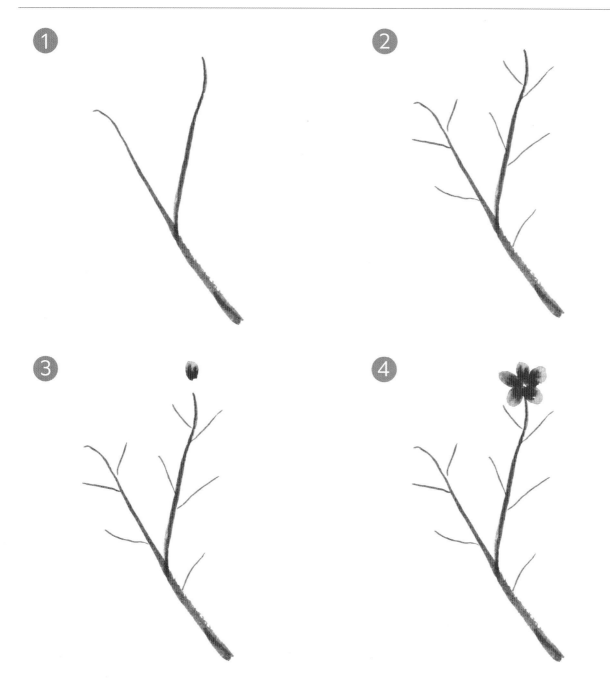

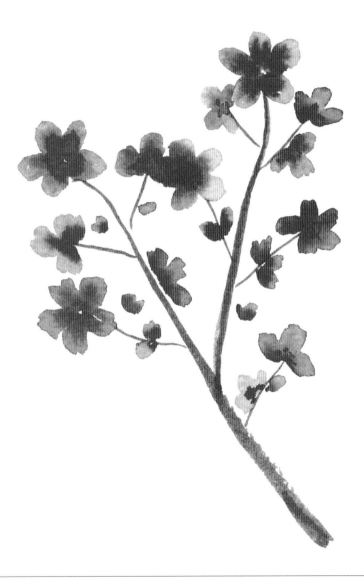

GOOD TO KNOW: Paint the petals in a delicate shade of pink and dab a darker pink hue into the centres while the first layer is still wet. This will produce a more natural, softer colour progression.

You can decorate the branch further with a green leaf, or with stamens in the centres of the petals. These can be drawn in using a fine-tipped brush or a fineliner in a matching colour.

SUCCULENT WREATH

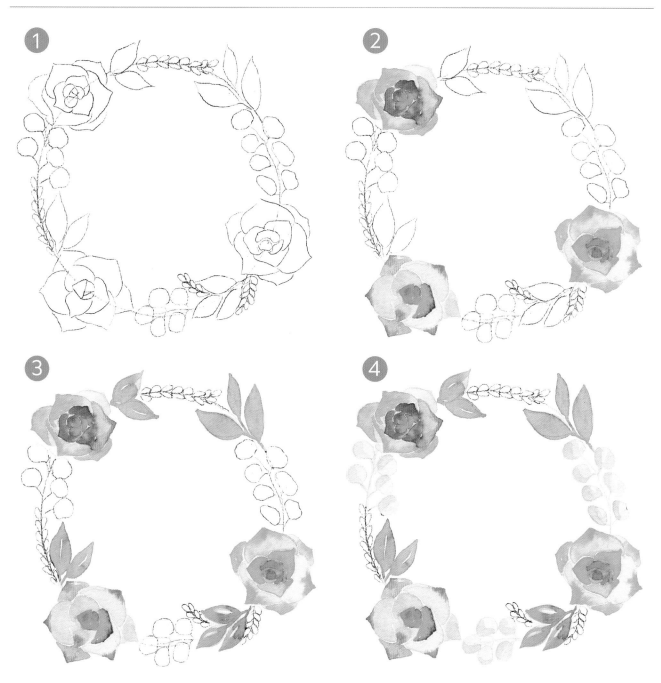

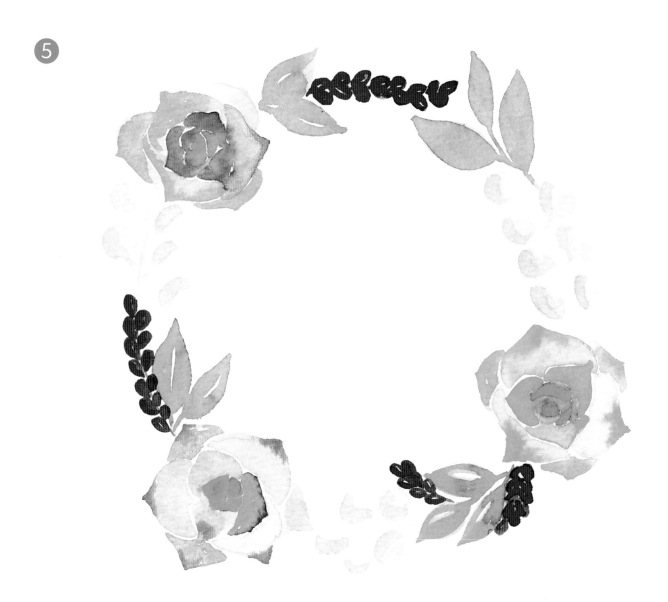

GOOD TO KNOW: You can find most of the elements of the succulent wreath, apart from the smaller details, on pages 42–45 and 78–79.

You can look at the floral and leaf wreaths on pages 34–35, 52–53, 64–65 and 76–77 for further tips on preliminary drawings, and on arranging the wreaths.

WATERMELON SLICE

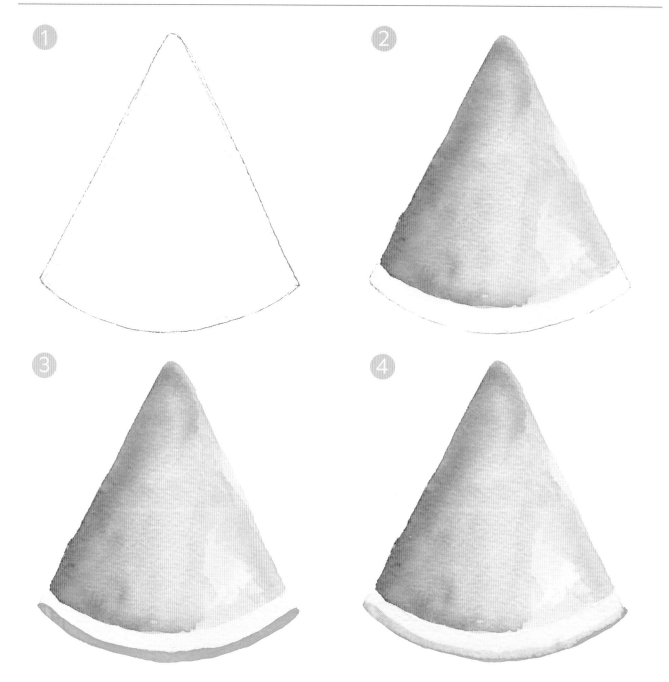

5

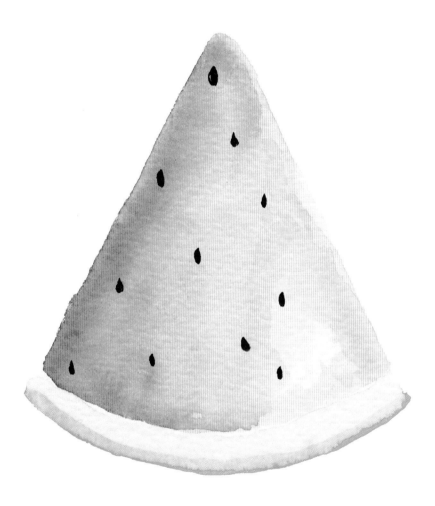

GINKGO

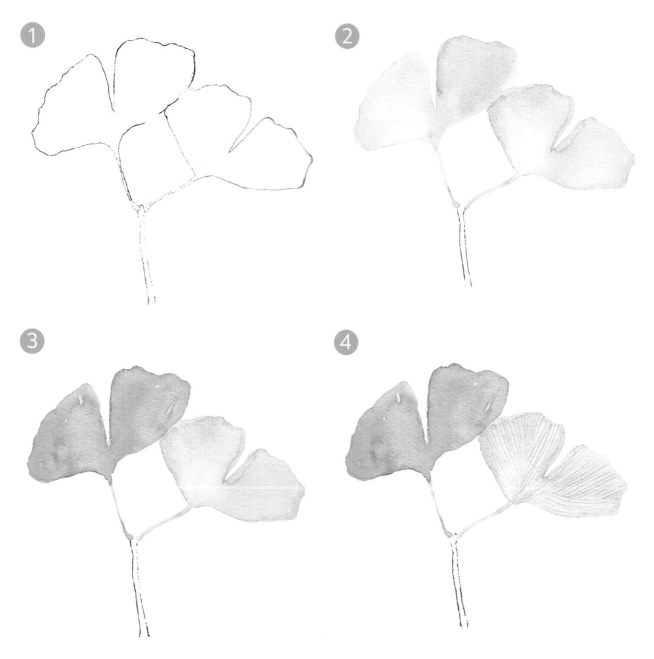

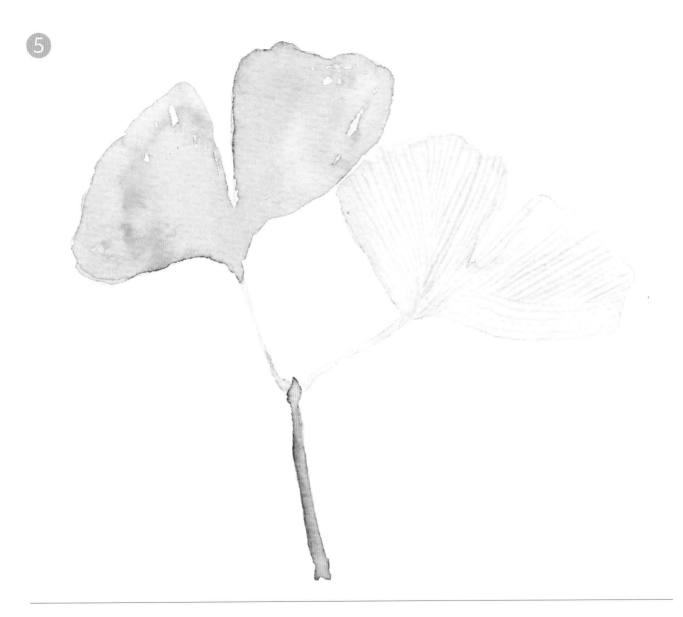

⑤

GOOD TO KNOW: Like most of the subjects in this book, you can draw the ginkgo leaf in different ways. You can see two of the ways here. First, paint both leaves in a soft base colour. Next, paint another layer of green onto one of the leaves and, using the same paint, draw very fine strokes through the other leaf. As soon as the motif is completely dry, you can paint in the branch in a shade of reddish-brown.

LOTUS FLOWER

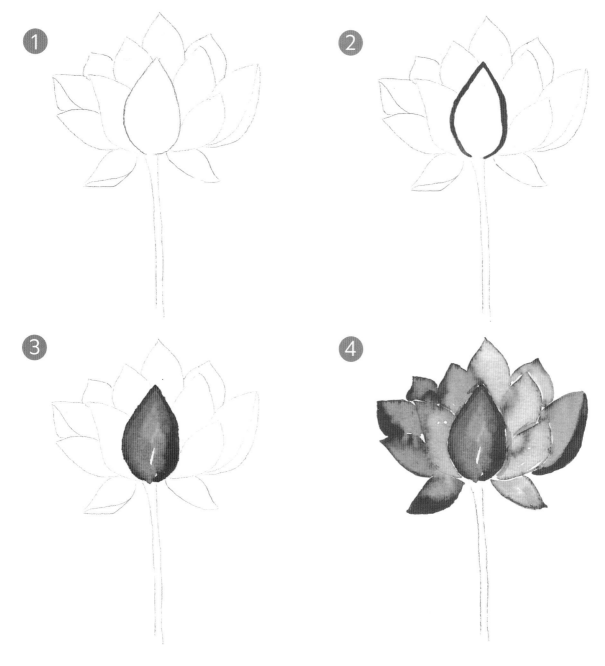

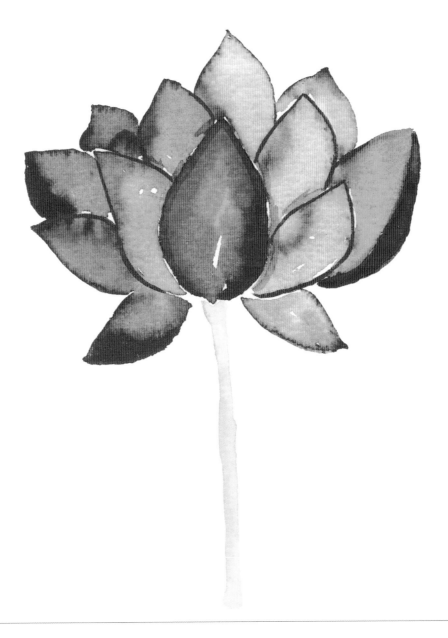

GOOD TO KNOW: For the lotus flower, it is important that the individual petals can be distinguished. You can ensure this by leaving white spaces in between the petals, or by adding a thin outline to each one using a bolder hue.

LEAFY BRANCH

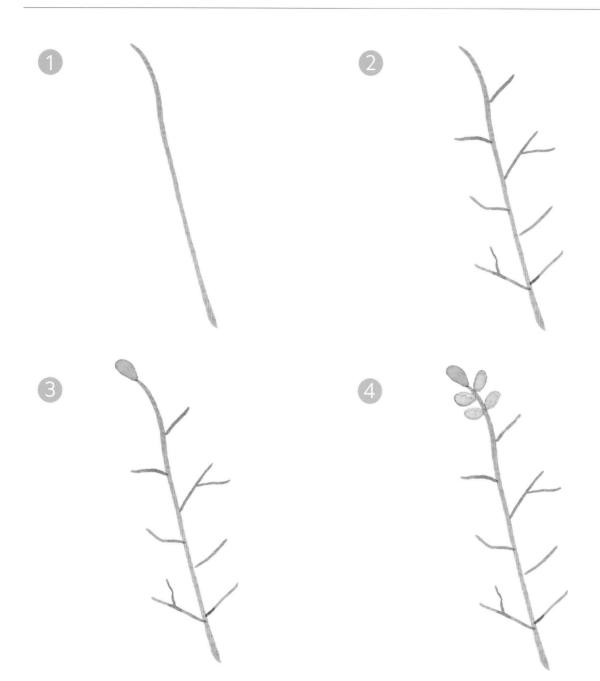

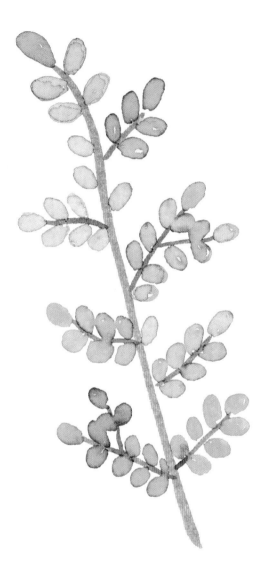

CHERRIES

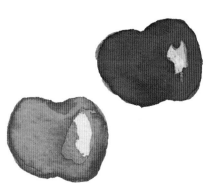

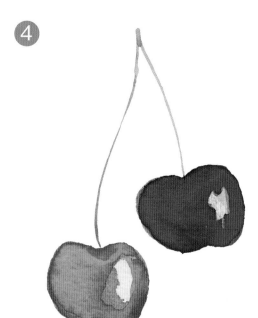

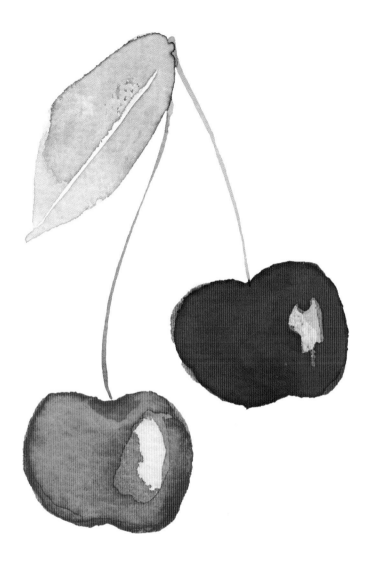

GOOD TO KNOW: First, paint the outlines of the cherries, then, using just water on the brush, spread the colour in towards the centres. Leave some white areas free to suggest reflections of light. If you like, paint in one of the cherries using a more intense shade. In places, dab the stronger colour onto the still-wet cherry and observe how the colour spreads. Practise painting the cherry leaves on pages 42–43.

INDOOR CACTUS

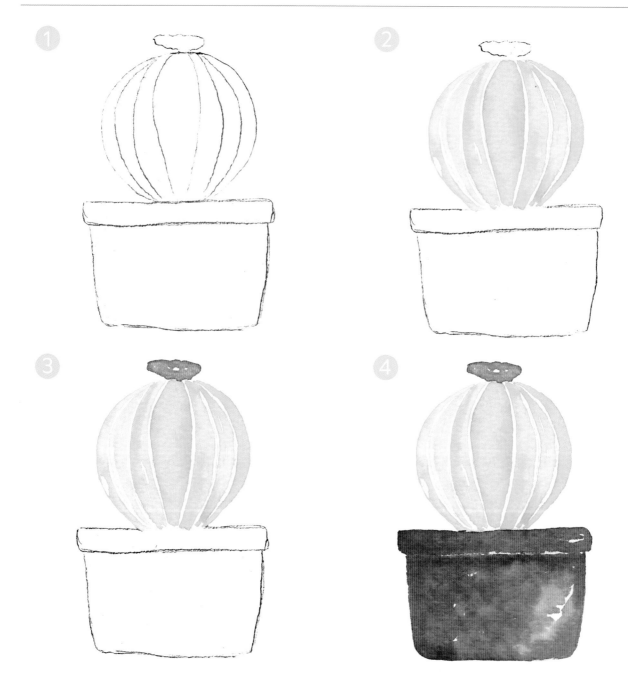

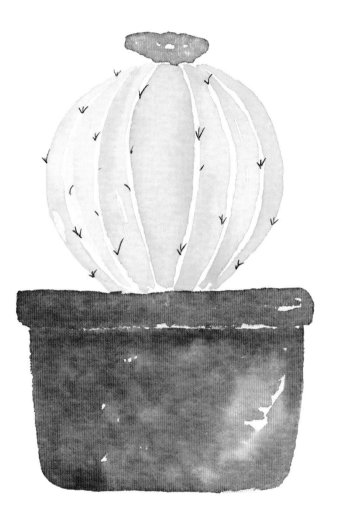

GOOD TO KNOW: You can split up this cactus lengthways with white, to give it more form and dimension. Add in the cactus needles with a fine brush or a fineliner when the other colours have dried.

ABOUT THE AUTHOR

Lena Yokota-Barth was born in Tokyo, Japan, in 1985 and grew up mainly in Germany. It was during her maternity leave, at the end of 2016, that she started her blog, 'Berries and Buttercup', which stemmed from her passion for watercolour painting and DIY projects. On her blog, Lena inspired her readers with colourful watercolours and DIY ideas.

During annual visits to her native country, Lena kept coming into contact with *etegami*, the Japanese style of watercolour painting. She never lost sight of this and, over the course of 2017, began to specialize in this form of watercolour painting.

Lena's artwork can be seen on her website: www.berriesandbuttercup. com and on her Instagram account: @berriesandbuttercup

ACKNOWLEDGEMENTS

A big 'thank you' to EMF-Verlag for the trust placed in me, the constant motivation words and the enjoyable collaboration. I would especially like to thank my editor, Anna Schmitt, for the helpful conversations and for sorting out my creative thoughts.

Huge thanks to my family – my husband, my daughter and my parents – for the support whenever I needed it. Without you, I probably would not even have dared to take on this exciting project.

EIN BUCH DER EDITION MICHAEL FISCHER

PUBLICATION DETAILS

Edition Michael Fischer GmbH, 2018
www.emf-verlag.de

This translation of *50x WATERCOLOR* first published in Germany by Edition Michael Fischer GmbH in 2017 is published by arrangement with Silke Bruenink Agency, Munich, Germany.

First published in Great Britain in 2019

Search Press Limited
Wellwood, North Farm Road,
Tunbridge Wells, Kent TN2 3DR

ISBN: 978-1-78221-738-1

Suppliers
For details of additional or alternative suppliers, please visit www.searchpress.com